D0897506

IMAGES
of America
DETROIT'S
CASS CORRIDOR

ELMWOOD PARK BRANCH
550 CHENE
DETROIT, MI 48207

APR 2013

EL

On the Cover: In 1896, Ransom E. Olds drove the first gasoline-powered carriage through the streets of Detroit, and the city and world would be forever changed. In 1946, the city of Detroit celebrated the golden jubilee of that first local automobile. This enthusiastic crowd celebrated on Woodward Avenue, the city's main street and the Cass Corridor's eastern boundary. (Reuther Library.)

IMAGES
of America
DETROIT'S
CASS CORRIDOR

Armando Delicato and Elias Khalil

ARCADIA
PUBLISHING

Copyright © 2012 by Armando Delicato and Elias Khalil
ISBN 978-0-7385-8268-9

Published by Arcadia Publishing
Charleston, South Carolina

Printed in the United States of America

Library of Congress Control Number: 2011937252

For all general information, please contact Arcadia Publishing:
Telephone 843-853-2070
Fax 843-853-0044
E-mail sales@arcadiapublishing.com
For customer service and orders:
Toll-Free 1-888-313-2665

Visit us on the Internet at www.arcadiapublishing.com

This book is dedicated to the people—past and present—who have called the Cass Corridor home. Their spirits energized and compelled us to share and immortalize a great American story.

CONTENTS

ACKNOWLEDGMENTS

We gratefully acknowledge the generosity of the people and photographers who shared their extensive knowledge of the life and times of the Cass Corridor through anecdotes and images, notably: George Boukas, Sergio DeGiusti, Pat Dorn, Gary Frundel, Michael John, Joel Landy, John Linardos, Scott Lowell, Pat McNames, Nick Medvecky, Karen Nagher, Eddie Powers, Sharon Pyror, Ralph Rinaldi, Chuck Roy, Dan Scarsella, Allen Schaerges, Bob Sestok, Robert Slattery, and Robin Sommers.

We are indebted to many people who responded enthusiastically to requests for time, information, and photographs, especially Annmarie Borucki and Sue Mosey of Midtown, Inc.; Robert Houlihan of the *Detroit News*; and Leni Sinclair.

We gratefully acknowledge the photographic and technical assistance of Elizabeth Clemens of the Walter Reuther Library at Wayne State University, Asili Mugei Deeb, Marco Petricca, Marian Christensen, and Rose Riopelle, without whose effort this book would not have been completed.

Finally, we would like to thank our friends, family, and each other for the inexhaustible patience, understanding, and encouragement throughout this lengthy process; we are truly blessed to have you in our lives.

The images in this volume appear courtesy of Asili Mugei Deeb (AMD); Avalon International Breads (AB); Armando Delicato (AD); Burton Historical Collection, Detroit Public Library (BH); Brenda Shea (BS); Bird Town owners Gary Frundel and Pat McNames (BT); City Bird (CB); Douglas Ekman (DE); Dave Lewinski (DL); *Detroit News* (DN); Dante Stella (DS); Elias Khalil (EK); Francis Grunow (FG); Felipe Puerto-Aragon (FP); John Linardos (JL); Library of Congress (LOC); Leni Sinclair (LS); Megan Brady (MB); Marian Christensen (MC); Midtown, Inc. (MD); Marco Petricca (MP); North Cass Community Union (NCCU); Nick Medvecky (NM); Pat Haller (PH); Preservation Wayne (PW); Rose Riopelle (RDR); Reuther Library (RL); Ralph Rinaldi (RR); Robert Sestok (RS); Rick Vian (RV); Sergio DeGiusti (SD); Scott Lowell (SL); Sandy Mush (SM); Robert Ray (RBR); Bronx Bar (BB); Marilyn Sunderberg (MS); Willys-Overland Corp. (WO); Michael Johnson (MJ); James Luzenski (JL); Dennis Pruss (DP); George Boukas (GB); Ken Mikolowski (KM); Detroit Institute of Arts (DIA); and Downtown Detroit Partnership and M-1 (DDP/M-1).

INTRODUCTION

Founded by the French in 1701, Detroit became an American city after the Revolutionary War. During the 18th century, French settlers were granted land in long narrow strips referred to as "ribbon farms" that ran from the Detroit River into the forests of the interior. These farms formed the pattern for the later development of the city.

In 1805, the old city burned and a new town was developed along the lines of the ribbon farms, as well as with a major street, Woodward Avenue, which served as a dividing line between the east and west sides of the new town. When Michigan became a territory, officials were sent from the Atlantic Seaboard states to prepare the west for eventual statehood. As the American presence expanded, many of the old ribbon farms were bought by new settlers. Lewis Cass, territorial governor from 1813 until 1831, bought a farm that ran due west of Woodward Avenue for several miles. That parcel eventually became the Cass Corridor.

Growth was slow on the frontier until the mid-19th century when the Erie Canal connected the region to the Atlantic coast and immense deposits of natural resources were discovered in the Upper Peninsula of Michigan. When the railroad came into general use by the 1870s, industrialization proceeded at a brisk pace. The city grew rapidly as industries were founded and wealth was created. By the end of the Civil War, the growing upper middle class (the founders and managers of the new industry and commerce) looked to the open countryside to build their new homes that befitted their status in the community.

The majority of the early inhabitants of this upscale neighborhood were the gentry of the growing, prosperous city of Detroit. While many of the immigrants who flocked to the city settled in ethnic neighborhoods on the east and west side of downtown Detroit, the Cass Corridor, on the north side of the city, remained a middle- and upper-class Anglo-Saxon community that supported the important Protestant churches.

With the dawn of the 20th century, the growth of the automobile industry and the immense demographic and economic growth that occurred impacted the Cass Corridor, even more than some of the other neighborhoods in the city.

As the wealthy families built bigger, more modern houses farther from the center of the city, their old houses became home to thousands of migrants from the South. African American migrants were steered to the east side of Woodward Avenue, while thousands of Appalachian migrants settled to the west in the former mansions that had been subdivided into small apartments. Automobile-related industries were incorporated into existing buildings or new buildings were rapidly constructed to meet the growing need for space. The congestion that resulted turned the former bucolic residential community into a bustling urban area that accelerated migration of the wealthy out of the neighborhood. Anchored on the north by the growing Wayne University, the area managed to develop an element of the bohemian character that would define it in later years. Several cultural institutions were located in or near the area, including Orchestra Hall, home of the Detroit Symphony Orchestra; the Detroit Institute of Arts; the main Detroit Public

Library; and the Masonic Temple featuring a huge auditorium. Many venues designed for more popular entertainment were built, especially along Woodward Avenue, the eastern boundary of the Cass Corridor.

By the middle of the 20th century, the Cass Corridor was home to the poor and attracted some of the seamier elements of the growing city. Even cultural institutions, such as Orchestra Hall, fell into disuse, and the neighborhood became known as a slum. There was talk among the city's leaders of demolishing the whole area and redeveloping it from scratch. Fortunately, inertia would ultimately save much of the area's architectural integrity.

The next phase of the Cass Corridor stamped the community with a new identity. The 1960s was a decade of revolutionary social change in Detroit, the United States, and, indeed, the entire world. In proximity to the present-day Wayne State University, inexpensive housing with character and the legacy of the beatnik movement of the late 1950s created a draw for artists, musicians, political activists, students, and professors. The Cass Corridor became the center of activism in the region, with lasting implications for the modern community that is emerging during the 21st century. The Cass Corridor was becoming Detroit's version of New York's Greenwich Village. For several decades, the neighborhood would teeter between decay and resurgence. Lack of basic services and a concentration of social agencies seemed to ensure that the Cass Corridor would be home only to the poor and the desperate.

Fortunately, the residents of the Cass Corridor would not allow it to be destroyed. Proactive average people took matters into their own hands, preserving the best of the past while creating growth and maintaining diversity.

Today, as part of the rebranded area of Detroit named Midtown, the Cass Corridor is undergoing a rapid transformation in which the past and the present are the foundation for a renewed city. Several organizations and visionaries have renovated old buildings for commercial or residential use while encouraging new construction on vacant property. The Midtown community, the center of the growing creative class in the city, is a model for sensitive, earth-friendly development. The future looks bright for this vital part of the city of Detroit.

One

THE VICTORIAN ERA

By the mid-19th century, Detroit was poised to begin a period of incredible growth. The discovery of raw materials in the Upper Peninsula, growth of the railroad, and improved water transportation all contributed to the development of industry in the city.

The captains of industry were predominantly descendents of the Anglo-Saxon Protestant gentry that had migrated to Detroit from New York and the New England states. As their wealth grew, many decided to build their homes in the newly subdivided plots west of Woodward Avenue and north of downtown. In 1871, Mary Cass Canfield subdivided the ribbon farm she inherited from her father. Since the area had been known as the Cass Farm—named after Lewis Cass, former governor of Michigan and candidate for the US presidency in 1856—the first street that paralleled Woodward Avenue to the west was named Cass Avenue. On the tree-lined streets that were laid out, the wealthy Detroiters built their Queen Anne and Italianate homes.

The brick streets would resonate with the sound of horses' hooves as their owners set out to pursue business and social interests. Fortunately, a number of these homes have survived the stresses of change in the city during the 20th century and are restored today. There are six national historical districts in the Cass Corridor, reflecting the desire of residents to preserve the best of the past while building for the future.

The genteel community thrived through the end of the 19th century, however, it faced a radical transformation with the incredible growth and wealth of Detroit as the automobile industry developed in the early 1900s. The neighborhood would undergo a number of striking changes during the 20th century and into the 21st century.

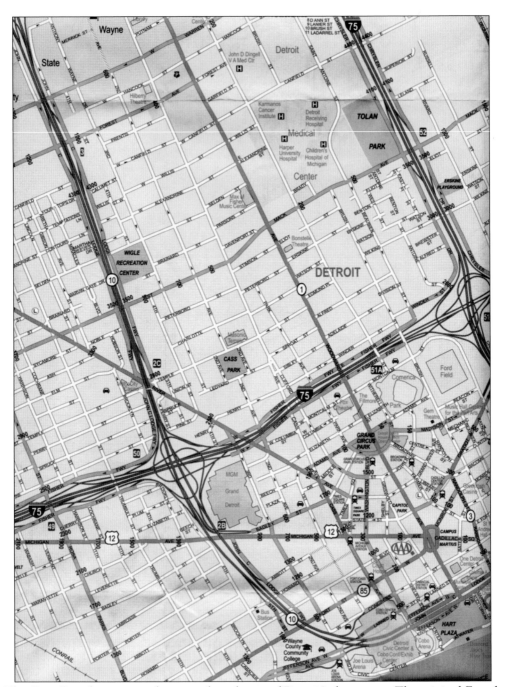

The Cass Corridor is situated just north and west of Detroit's downtown. The original French settlement hugged the river and followed the boundaries of the ribbon farms—the narrow strips of land granted to French settlers. As a result, the major streets in the older parts of the city run on an angle from the southeast to the northwest. The information in this book is limited to the area north of Interstate 75, west of Woodward Avenue (M1), east of the Lodge Freeway (M10), and south of Warren Avenue. However, the Cass Corridor is a state of mind that transcends geography. (AD.)

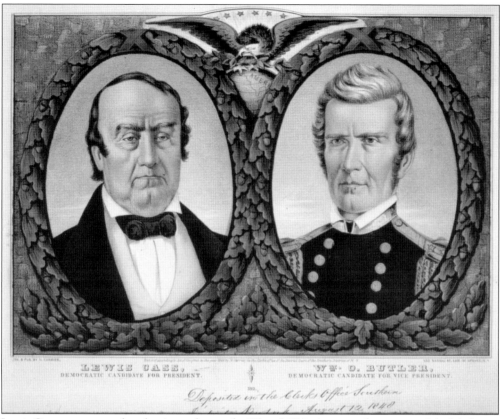

Lewis Cass was a general in the Army during the War of 1812. Appointed governor of the Michigan Territory in 1813, he served for 18 years before becoming secretary of war under Pres. Andrew Jackson. After serving as ambassador to France, he was sent to the US Senate by the Michigan State Senate. Nominated by the Democratic Party as their candidate for the presidency in 1854, he was defeated. Pictured is a campaign poster with Cass on the left and his vice presidential candidate, William Butler, on the right. (LOC.)

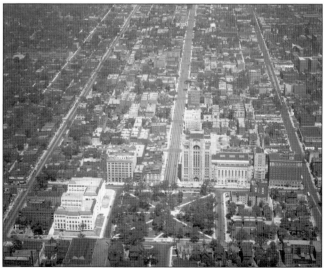

This aerial view of the Cass Corridor faces north from Cass Park toward Second Avenue, which bisects the neighborhood. Several of the major buildings remain; Cass Park is bordered by the former S.S. Kresge Company headquarters in the lower left foreground and the Masonic Temple in the center. (RL.)

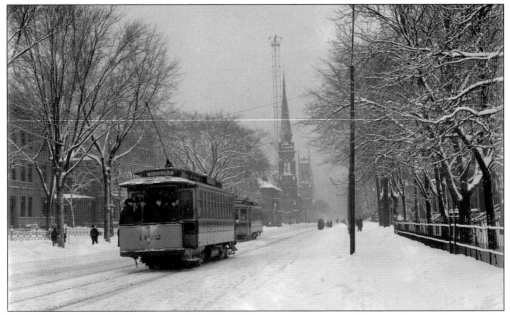

This beautiful, tranquil scene on Woodward Avenue was captured on a wintery afternoon in the 1890s. The narrow residential street, with only electric streetcars moving to and fro, was about to undergo an enormous transformation, becoming the main street of the rapidly growing metropolis. (LOC.)

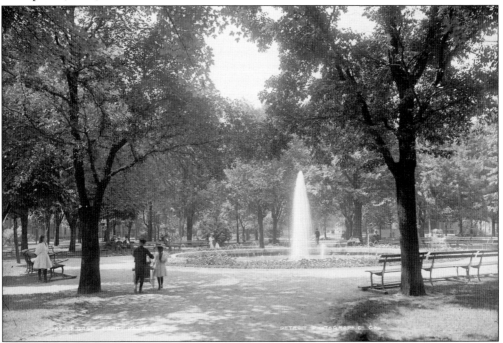

When Cass Park was deeded to the city, it was somewhat controversial because it was so far north. However, the community quickly grew around and north of it, and Cass Park became a very popular respite for Detroiters. The fountain in the center of the park is no longer there, but it is still a place to relax for the current residents of the neighborhood. (LOC.)

The view of Second Avenue above was taken from the east side of the street while looking north toward Cass Park and its fountain, and the view below was captured on the west side of the street, looking in the same direction. Despite the intrusion of a large, elegant apartment building on the east side of the street, the avenue would be typical of any wealthy community during the Victorian age. Most of these structures were ultimately demolished and replaced by large apartment houses. (Both, JL.)

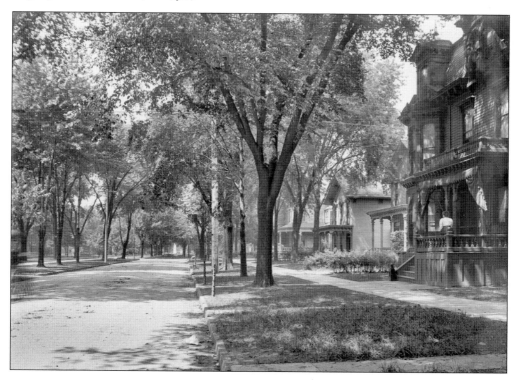

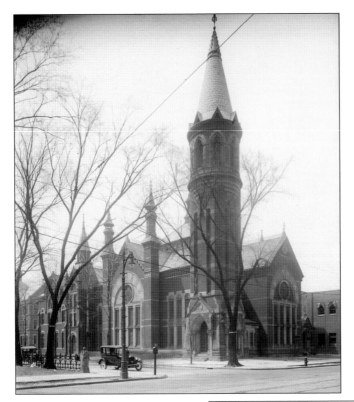

Westminster Presbyterian Church was built on the northwest corner of Woodward Avenue and Parsons Street in 1876. Because of the affluence of most of the residents of the area and the number of churches they built, the neighborhood was dubbed "Piety Hill." This building served the congregation until 1919 when the church was demolished to make way for Orchestra Hall. (RL.)

Dedicated in 1883, this house of worship was christened Cass Avenue United Methodist Church. Reflecting the affluent congregation of the time, the quality of the decorations was exceptional. Tiffany windows and wooden ceiling beams contributed to the beauty of the building. Still in use, the church is now in its third century of service, and its congregation is distinguished by its commitment to social justice and service to the poor. (MP.)

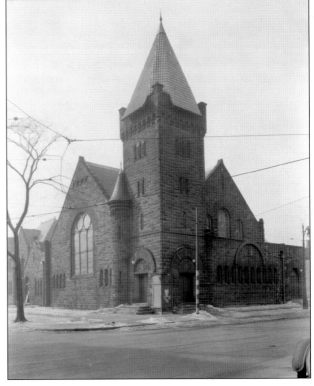

The Unitarian Universalist Church used the McAdow house on Cass Avenue and Prentis Street for the first few years of its existence before erecting this Gothic-style church building that continues to serve its congregation in the 21st century. The church has played an important role in the spiritual, cultural, and political life of the Cass Corridor up to the present time. (MP.)

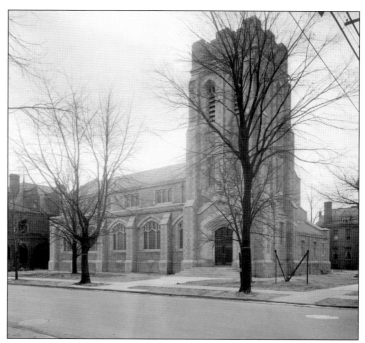

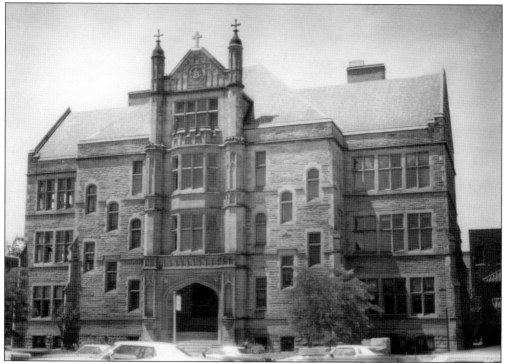

By the time a substantial number of Detroit's Catholics had reached the prosperous middle class in the 1890s, the property located on the north side of Parsons Street and west of Woodward Avenue became the site of a school that was named for SS. Peter and Paul. As the Catholic elementary student population declined by the 1940s, the school became the Girls' Catholic Central High School. Today, it houses St. Patrick's Senior Center. (MP.)

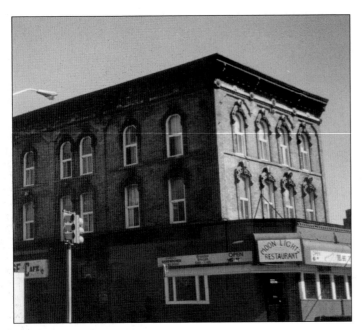

The Park Davis Pharmaceutical Company's original home was situated at the corner of Cass Avenue and Henry Street. Park Davis was organized in 1867 and grew to become, for a time, the world's largest pharmaceutical company. Its rapid growth led to it moving from this building (seen here in the 1960s) constructed around 1870 to a much larger and grander campus along the Detroit River. After a fire in the early 2000s, this building was demolished. (AD.)

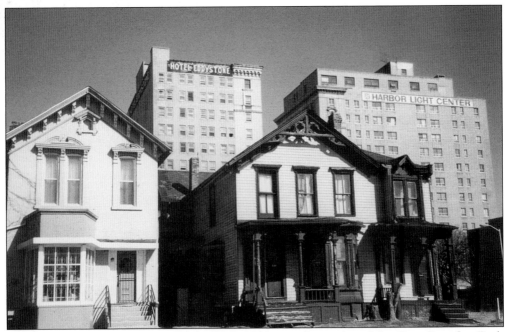

The two houses shown above are carryovers on the southern edge of the Cass Corridor. Both were built by A.E. Bigelow, a lumber dealer, and they remained single-family homes for many years. The house on the left was remodeled in 1941 to include the nontraditional bay windows and a modern door. In 1965, it became an antique shop. The house on the right was purchased by George Hancock in 1875. Both buildings were occupied until the 1990s; they are now in need of careful restoration. (RDR.)

16

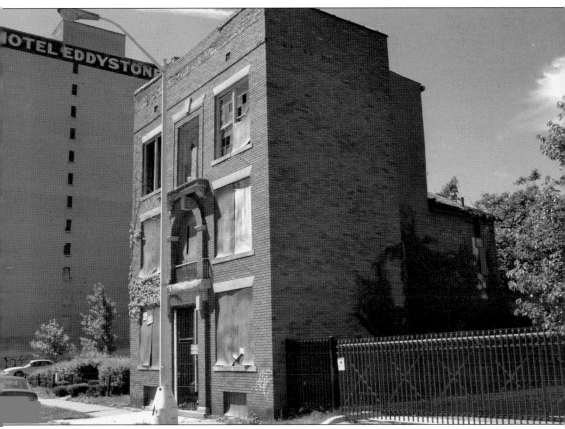

This original frame house, built around 1861, seems to be buttressing the three-story apartment house that was added to the front in 1912. Mae Cole, the widowed owner, remodeled it to provide rental accommodations and create income. The city was growing very rapidly at that time, and she had no problem finding tenants. It continued as an apartment house until it was abandoned in the 1990s. (RDR.)

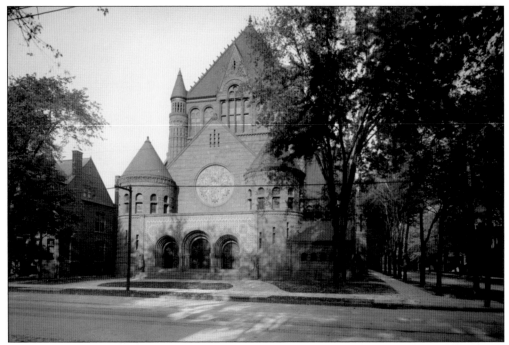

Victorian residents of the Cass Corridor often referred to their neighborhood as Piety Hill because of their support of the leading churches in the city. First Presbyterian Church on Woodward Avenue reflected the wealthy membership with its elaborate stained-glass windows (including one by Tiffany of New York) and beautiful architecture. (PW.)

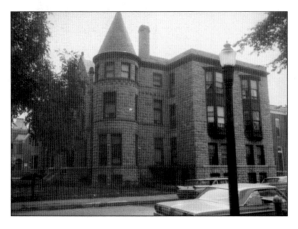

Designed in Victorian Romanesque style, the Scott Castle was an imposing structure dominating a street with many outstanding buildings. James Scott was a developer who was prominent in the southern portion of the Cass Corridor. Records show that it was turned into an apartment house in 1913 to accommodate the huge population growth in the city at that time. Despite a turnover in ownership during the late 20th century, the building still awaits adaptive reuse. (PW.)

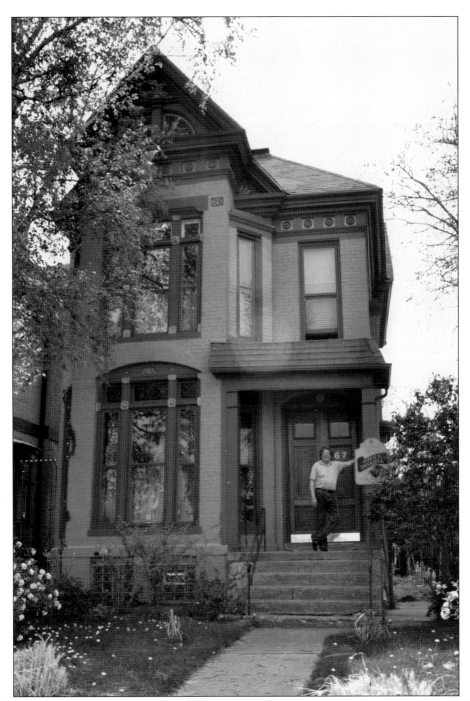

Built in 1882, this Victorian structure was home to a number of prominent Detroit families. In 1900, the house was sold to retailers Robert and Elizabeth Tannahill (note the incorrect spelling on the sign in the image). Elizabeth was the sister of J.L. Hudson, founder of the J.L. Hudson Department Store. Their son J.L. Hudson Jr. (who took his famous uncle's name) was president of the iconic Detroit department store chain for many years. The house has remained occupied throughout its history. Pictured on his porch is the current owner and restorer, Robert Ray. (RDR.)

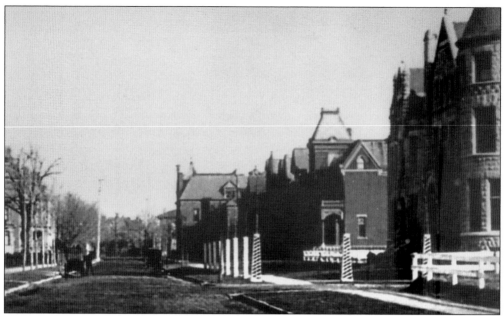

During the Gay Nineties, Peterboro Street was a quiet, unpaved thoroughfare that was home to Detroit's wealthy gentry. Note the carriages ready for proprietors to bring horses from the carriage houses for going into the center of the city. Soon, the quaint Victorian scene would change dramatically. This view is looking east on Peterboro Street from Cass Avenue in 1900. James Scott's castle is on the right. (RBR.)

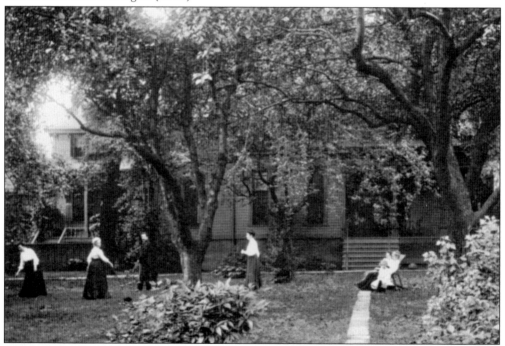

Another example of the bucolic nature of the upper-class community during the 1890s is this picture of a family playing croquet on a front lawn on Selden Street. The house and lawn would soon be replaced by an automobile parts warehouse. (PW.)

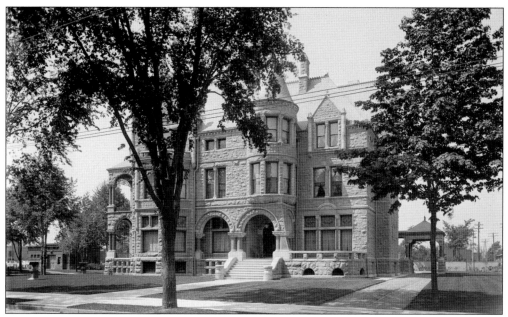

One of Detroit's wealthiest businessmen during the pre-automobile era was David Whitney Jr. By 1890, he built this magnificent structure that set the tone for opulence in the rapidly growing industrial city. Luckily for Detroit, the building was bought by the Visiting Nurses Association, and in 1986, it became an elegant restaurant, incorporating the high-end appointments installed by Whitney. (LOC.)

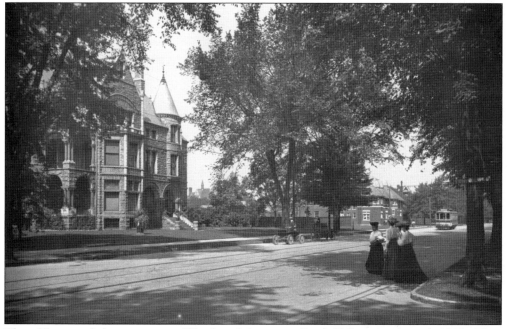

These Victorian ladies are crossing Woodward Avenue at Canfield Street in the early 1900s. They may be planning to visit the David Whitney family at their home in the mansion on the left or planning a shopping trip via the streetcar. The Detroit Athletic Club in the right center would be off-limits to them since it was a male-only club at the time. (LOC.)

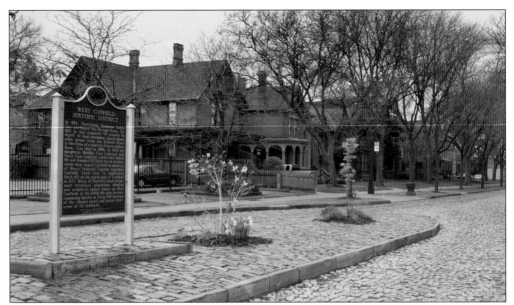

In 1871, prosperous Detroit families began building their elegant homes in the popular Victorian styles of the era. Canfield Avenue was one of the prestigious blocks in the neighborhood. As the result of the work of the Canfield-West Wayne Preservation Association in 1969, the block between Second and Third Avenues became the first of Detroit's historical districts. It was listed on the National Register of Historic Places. (RDR.)

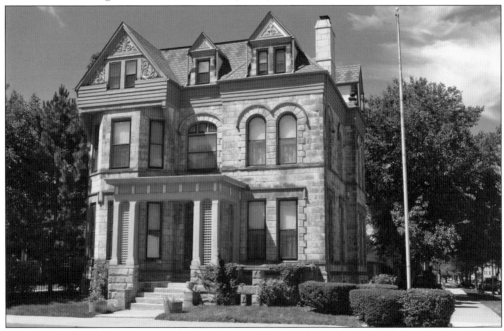

Campbell Symington came to Detroit from Scotland as a child. By the 1870s, he was able to have this magnificent house built for his family on Second Avenue. Using red sandstone, the house has an amazing variety of wooden carvings and decorative stone. It was, for a time, the office of the Dry Cleaning Institute, and then it was the Ronald McDonald House serving the Children's Hospital of Detroit. The building is well maintained to this day. (RDR.)

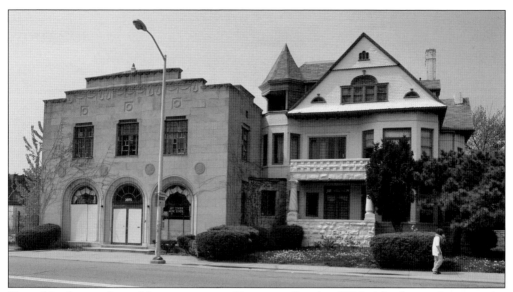

Harry Houdini performed his magic act in Detroit in October 1926. After his performance, he became ill and died in Grace Hospital. His body was taken to the Hamilton Funeral Home (seen here) on Cass Avenue before it was sent back to New York for burial. The building shown in the image consists of two parts. The original house on the right was completed in 1891 and home to the Robert and Jennie Brown family. The Art Deco mortuary building, in sharp contrast to the original, was added in 1930. (RDR.)

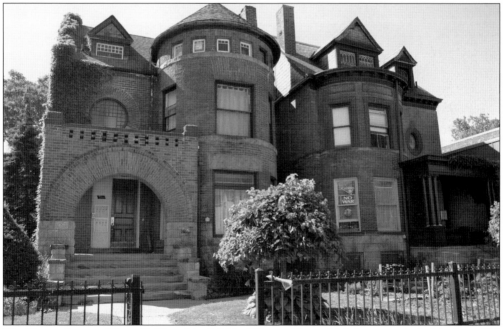

The George Loomer House (left) and the Mulford Hunter House (right) were typical of the beautiful residences built in the Cass Corridor. Both were erected in the 1890s; the Loomer House was modeled in the Richardsonian Romanesque style, which was very admired at the time, and the Hunter House was designed in the Queen Anne style. The houses are now divided into several apartments each. (RDR.)

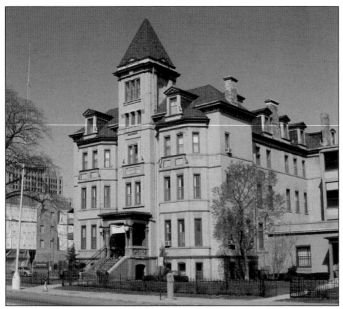

Without the modern opportunities to amass a legacy, widowhood was a frightening experience, even for women of means. Mary Thompson used money bequeathed by her husband David to build a home for widows. It was called the Thompson Home for Old Ladies, a name immortalized in stone over the front facade of the building. The building continued to serve its purpose until 1977, when it became home to Wayne State University's School of Social Work. (MC.)

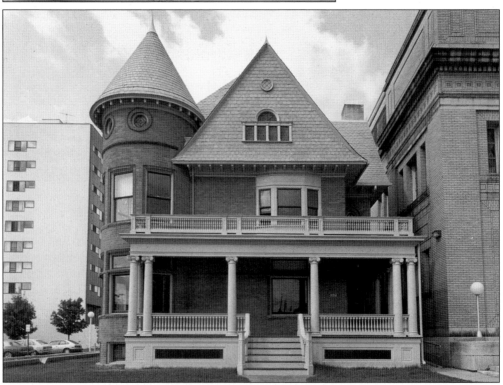

When the new Central High School opened on Cass Avenue in 1896, David Mackenzie served as its first principal. His home, shown here, was built in 1895, one block south of the high school building. This building was slated to be torn down in the early 1970s, but a group of students organized as Preservation Wayne and convinced the university to spare the structure. It now houses the offices of Preservation Wayne, an organization dedicated to preserving Detroit's architectural gems. (PW.)

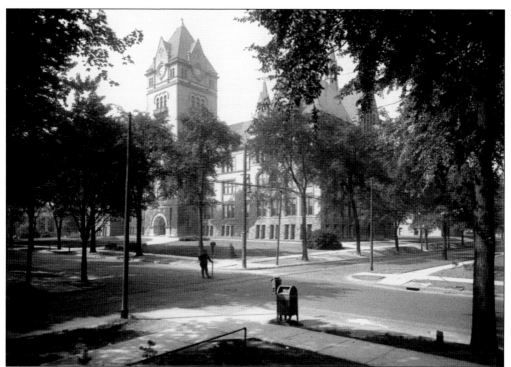

In 1896, Detroit had matured enough that the city built its first planned public high school, Central High School. In this scene, the policeman in the middle of Warren and Cass Avenues waits to direct traffic. In 1923, the school became the College of the City of Detroit. By 1933, it was the foundation of what is now Wayne State University. Known as "Old Main," it remains the icon of the university. (LOC.)

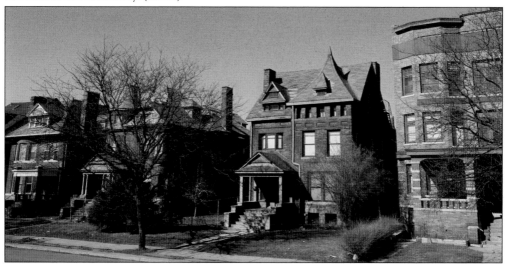

Horace Dodge, who, along with his brother John, played a prominent role in the early days of the developing automobile industry, moved to this house on West Forest Avenue in 1904. Although it had been divided into small apartments by the 1930s, the integrity of the building was preserved. By 1911, the enormous fortune earned by the Dodge brothers propelled them to build mansions on Lake St. Clair in Grosse Pointe. (MP.)

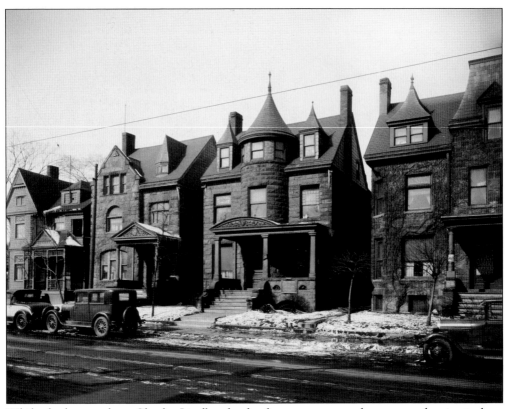

While the house where Charles Lindbergh, the first person to make a transatlantic airplane flight, was born is no longer standing, it is an interesting example of the type of residential architecture that existed in the Cass Corridor neighborhood during the late Victorian era. This house on Forest Street, a block west of Fourth Street, was demolished to make way for Wayne State University's athletic field. (RL.)

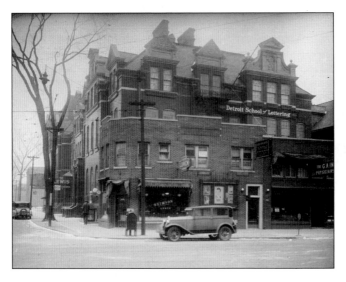

In 1891, Perry McAdow had this outstanding Renaissance Revival residence built on Cass Avenue and Prentis Street. He made a large fortune in Montana during the gold rush, as well as in land speculation. After marrying his wife, Clara, they decided they should live in a growing cosmopolitan center and moved to Detroit. The commercial additions have been removed, and the building is the parsonage for the Unitarian church next door. (RL.)

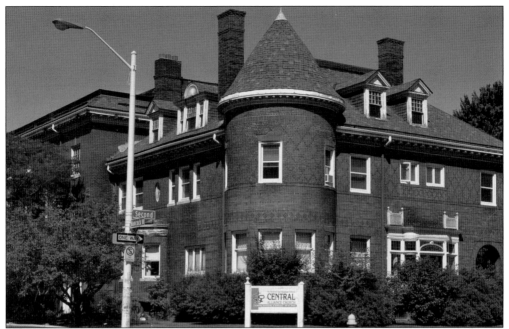

This imposing structure on the corner of Second Avenue and Hancock Street was one of the first buildings in the northern part of the Cass Corridor. It is an unusual combination of Romanesque and Colonial styles of architecture, with an interesting cylindrical tower overlooking the intersection. The three-story addition in the rear contains public space to accommodate the church that bought the property from the Butler family. The Central Alliance Church, reflecting the diverse population of the neighborhood, has joint pastors, one of whom is Chinese. (RDR.)

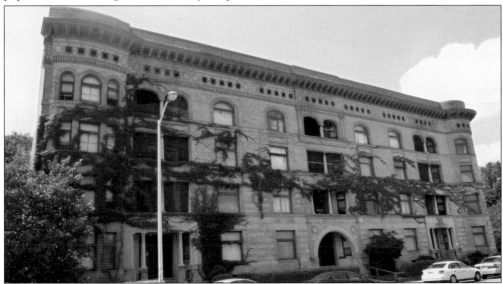

One of several apartment houses built in the 1890s for the affluent middle class, the Coronado continues to impress the passerby with its Richardsonian Romanesque architecture. In the 1920s, the building was renovated to increase the number of apartments for the lower-income residents who were moving into the neighborhood. After a period of abandonment, it was once again rehabilitated in the 1980s and remains one of the area's attractive affordable residences. (EK.)

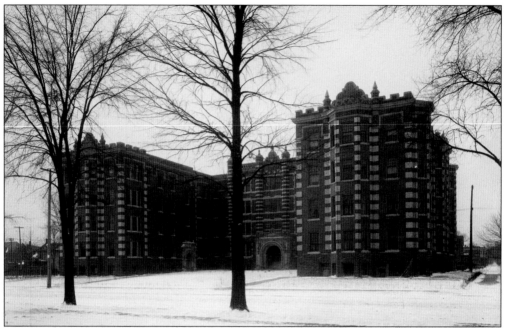

The Forest Arms Apartments is the largest apartment building constructed in the pre-automobile era of the Cass Corridor. It was built to attract a professional class of tenants, and its spaciousness, architectural appointments, and dramatic setback from the street were planned for that purpose. By World War II, the building had been adapted to house the rapid increase in Detroit's population of migrants from the southern states. Tragically, the building caught on fire in 2005 and was emptied. It will soon be restored. (RL.)

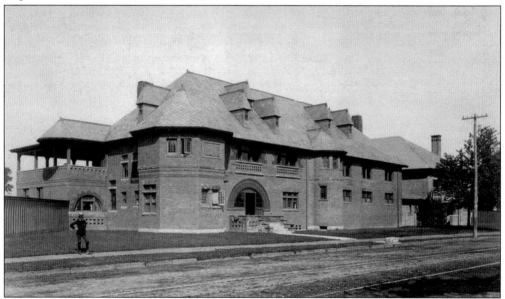

It was no coincidence that the Detroit Athletic Club, catering to wealthy industrialists and their sons, located its clubhouse in the Cass Corridor during the 1890s. Since most of the city's wealthiest citizens lived on either side of Woodward Avenue, they would have easy access to the facilities. By the 1920s, the Detroit Athletic Club sold this building and moved downtown. (LOC.)

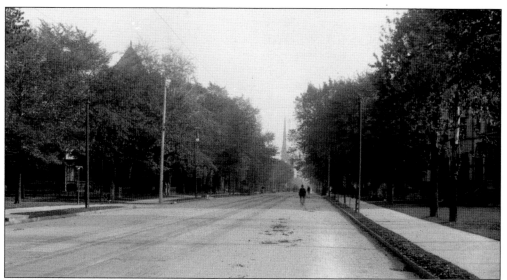

Woodward Avenue was essentially a main street for the homes of the wealthiest citizens of Detroit during the period that preceded the automobile industry. The street was lined with extraordinary houses and remarkable churches that the gentry attended. Soon, the street would undergo a thorough transformation. (LOC.)

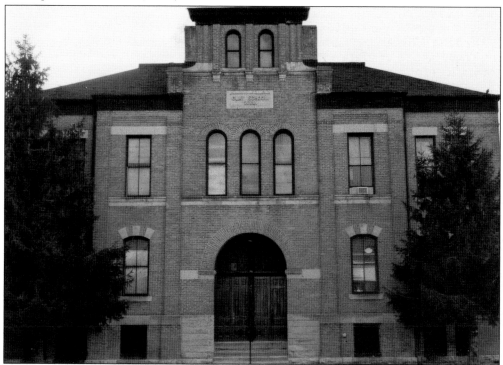

With the growth in population of the Cass Corridor following the Civil War, it soon became necessary to build schools. A frame school was built north of Cass Park and named the Clay School. It soon became inadequate for the growing neighborhood, so this brick structure was erected in 1888. It served until the 1960s, when it was bought by a law firm to serve as its headquarters. (PW.)

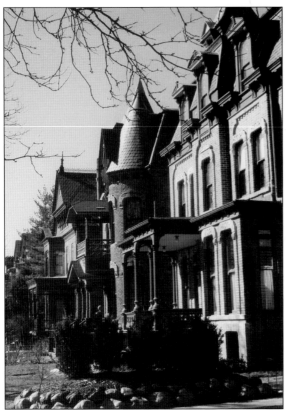

This panorama of Canfield Avenue reflects the look of the 1890s, as well as its current look. Unlike many of the buildings in the Cass Corridor, these houses have been continuously occupied and lovingly maintained. (FP.)

Before Detroit became the automobile manufacturing capital of the world, it manufactured locomotives, bicycles, wagons, and other items utilized for transport. This shop was the source of many parts that were used in putting together the first vehicle in 1896. Thus, the products created in this building on the southern edge of the Cass Corridor led to the enormous changes that would occur in Detroit, the United States, and around the world in the upcoming century. (BH.)

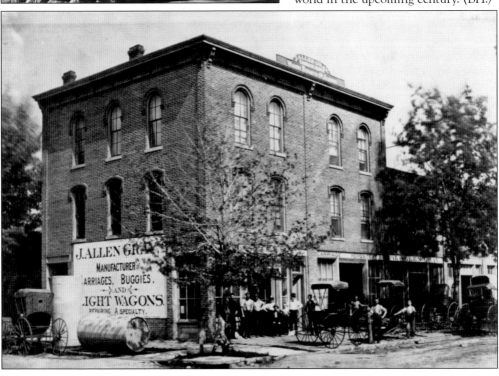

Two

EARLY 20TH CENTURY

The new century that began in 1900 ushered in a period of change to Detroit. The automobile industry would soon concentrate in Detroit and bring incredible wealth and spur tremendous growth in the city. Detroit was poised to be the center of what was to be a key industry in the then new 20th century.

These changes would be reflected in the Cass Corridor with both positive and negative effects. As many of the gentry gained wealth, they set out to newer neighborhoods, made possible not only by the prosperity brought about by the new industries but also by the mobility the automobile would provide.

During the early years of the century, new construction of iconic buildings, such as the Masonic Temple and the S.S. Kresge Company headquarters, were joined by the new home to the symphony at Orchestra Hall. Wayne University began to grow on the northern border on both sides of Warren Avenue, and automobile salesrooms and repair shops were opened. New residential construction trailed commercial and entertainment development. Along Woodward Avenue, dance halls, including the Graystone Ballroom, were thriving; the Convention Center was built on Cass Avenue and Canfield Street; and restaurants like Mario's on Second Avenue and many bars along all of the streets brought residents and nonresidents alike to the area for entertainment.

With the growing demand for workers and the movement of the wealthier residents to new neighborhoods, the character of the Cass Corridor changed.

Many migrants from southern states settled in the apartment houses and the newly subdivided mansions. The segregation of the era meant that African American migrants were confined to the east side of Woodward Avenue while the Cass Corridor remained a predominantly white community, though no longer dominated by Detroit's upper classes.

With the proximity of the major institutions of the city, the hospitals across Woodward Avenue, the downtown businesses and commerce, Wayne State University, and the Masonic Temple, the neighborhood retained a semblance of its former glory that would carry it into the next phase of its existence. The Cass Corridor would retain a shabby but somewhat dignified presence through the World War II years and into the 1950s.

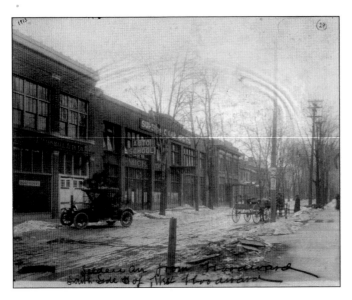

Detroit and the Cass Corridor were poised to undergo enormous transformations in the 1900s. The Cass Corridor would change from a wealthy, bucolic residential community into a commercial center with a less affluent population. These two vehicles—the horse and carriage on the right and the automobile on the left—on Selden Street west of Woodward Avenue represent the old and the new. Detroit and the Cass Corridor would never be the same. (BH.)

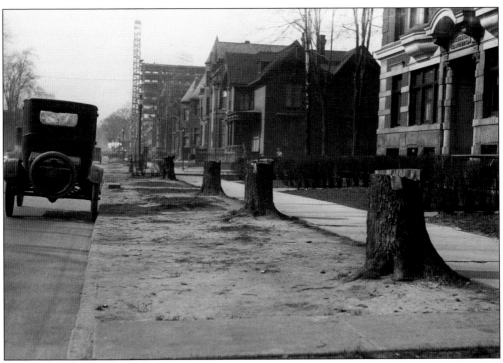

The tree stumps along Second Avenue were ubiquitous signs of the times in the early 1920s. The city was booming, and the Cass Corridor was the scene of tremendous growth. These houses would soon be gone, and large commercial buildings and apartment houses would replace them. (RL.)

This building, located on Second Avenue between West Canfield and Prentis Streets, has a typical Cass Corridor history. It housed automobile-related businesses throughout most of its history. Shown below is the exterior in 1920. The Model Ts are in front of the building, since parts for their bodies were constructed there before the Ford Motor Company built an enormous factory farther north in Highland Park. As seen above, it was also used for, among other things, an automobile salesroom. Now known as the Green Garage, its latest reinvention is a model of an environmentally responsible entity. (Both, JL.)

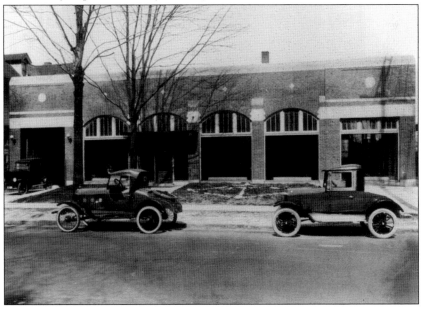

In the 1930s, Second Avenue was still a two-way street with many private houses lining it. The intersecting thoroughfare in the center is Canfield Street. Notice the large Victorian houses on the right. On the left, the gas station is now a parking lot for the Traffic Jam Restaurant that is on the corner directly across Canfield Street. (JL.)

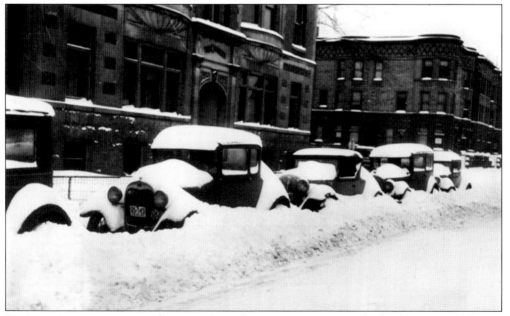

During a winter snowstorm in the 1920s, Second Avenue came to a standstill. These automobiles are parked outside of the Charles Apartment Building. Despite the changes that have occurred throughout the years, this scene is repeated every winter—only the vehicles have changed. (MS.)

This image shows a police officer next to a parked automobile on Fourth Street, just south of Hancock Street, in 1940. All of these buildings were demolished after the Lodge Freeway was constructed in the 1950s. The land that was not used for highway construction was utilized to build affordable housing, known as the Calumet Apartments. (RL.)

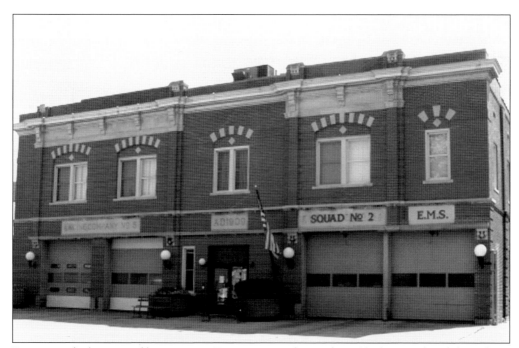

Protecting the homes and businesses in Detroit required a number of firehouses placed throughout the city. This fire station, located on West Alexandrine Street west of Cass Avenue, is one of the oldest still-functioning fire stations in the city. Its striking architecture reflects the architect's fondness for a medieval look combined with Renaissance motifs. (RDR.)

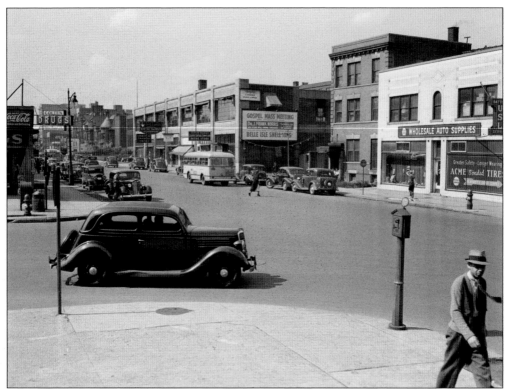

This is a scene of Cass Avenue looking north from Charlotte Street in the 1930s. In the distance is MacKenzie Hall, the student center for Wayne State University. The picture below was taken facing the other direction. In the distance is downtown Detroit. The traffic and pedestrians are reflective of the density of the area at that time. Many of the buildings pictured here, like the vehicles, no longer exist. (Both, RL.)

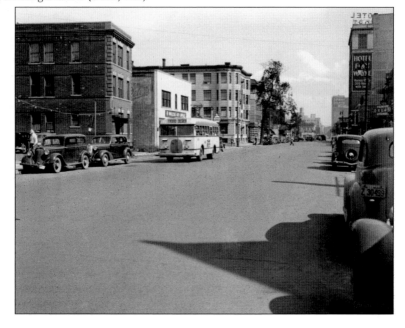

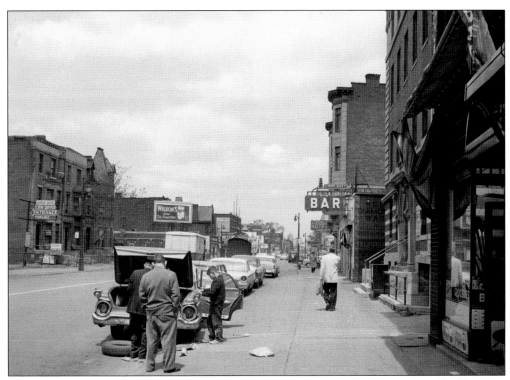

This view of Cass Avenue is a typical scene from the late 1950s. The neighborhood had become very run down, but there was still life on the street. Chinatown had begun to relocate to the area, and the population began to reflect the diversity of the region. (RL.)

In the 1920s, many of the newcomers to Detroit were young men who would work in the factories and make what was considered good pay at the time. Webster Hall, constructed on Cass Avenue and Putnam Street, provided 800 rooms and many amenities for men only. The building was eventually sold to Wayne State University and renamed Mackenzie Hall. It served as a dormitory and a student center until 1969, and in 1991, the structure was demolished in order to build a parking deck. (PW.)

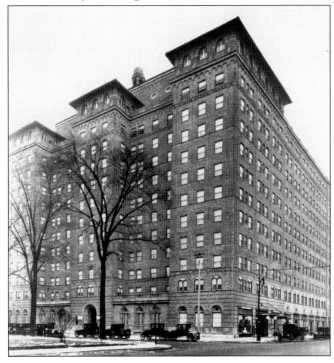

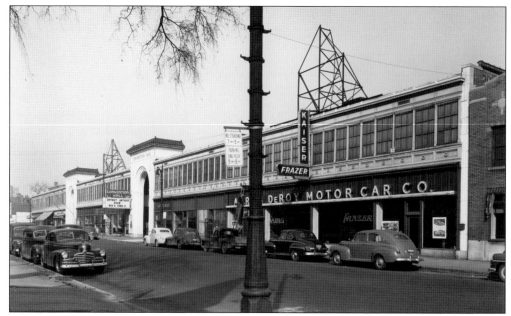

As Detroit became the international center of the automobile industry, it was necessary to have an appropriate showcase for the products. Convention Hall was constructed on Cass Avenue, extending east to Woodward Avenue, covering most of the city block. Storefronts were used as retail outlets, including the Kaiser Frazer showroom facing Cass Avenue. When the automobile shows outgrew even the Convention Hall, they moved to the newly constructed Cobo Hall downtown. The Convention Hall became an artists' studio and eventually was demolished. (BH.)

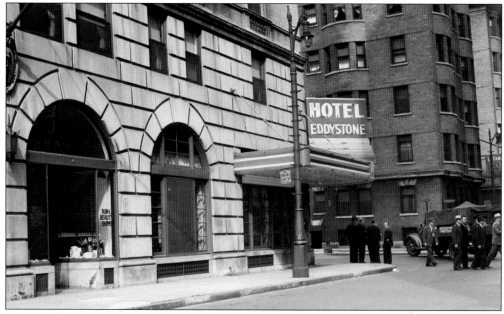

In the mid-1920s, many medium-rise residence hotels were constructed for the large middle-class population of the growing city of Detroit. The Hotel Eddystone and the Park Hotel (right) were very successful because of their proximity to Woodward Avenue and the downtown business district. (RL.)

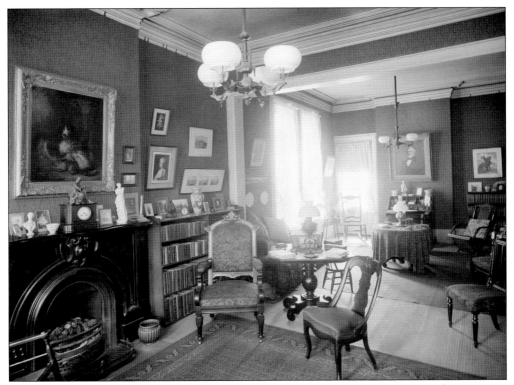

The way of life in the Cass Corridor was changing rapidly by the early 20th century. The Victorian elegance that had characterized the 19th-century homes was giving way to the growing dynamic industrial city. The interior of the Charles Livermore house on Henry Street (shown above) was soon to be outdated in the noisy, increasingly commercial neighborhood. (LOC.)

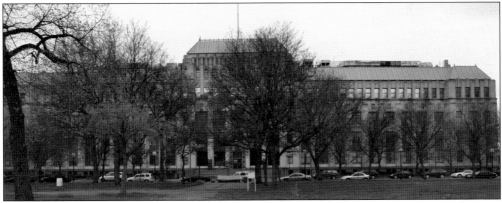

In the 1920s, the phenomenal growth of Detroit seemed to be pushing the commercial center north. Cass Park was losing its residential character and becoming an urban oasis. The S.S. Kresge Company had outgrown its downtown tower and erected this beautiful Albert Khan–designed Art Deco building. By 1972, the company donated this building to the Detroit Institute of Technology. They, in turn, left, and it became the Michigan Center for High Technology, an incubator institution for start-up companies. (AD.)

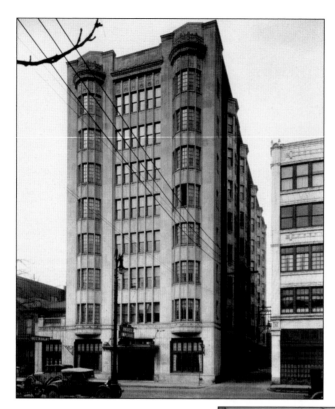

The Imperial Hotel was constructed, like most of the residential hotels in the area, during the 1920s. It is an eight-story building with a surprisingly contemporary appearance, even in the 21st century. Its elegant exterior and interior reflect the well-to-do clientele that frequented it. After a period of decline, the building was restored to serve the temporarily homeless and is known as COTS, the Coalition on Temporary Shelter. (PW.)

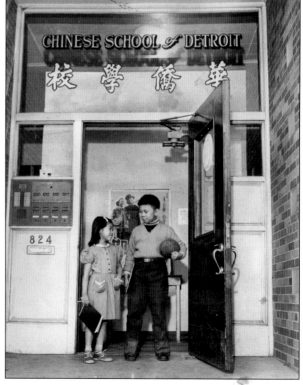

The only immigrant group that carved out a community in the Cass Corridor was the Chinese settlement that centered on Cass Avenue and Peterboro Street in the late 1950s. While not as large as Chinatowns in some other American cities, the community was able to support its own school on Cass Avenue in order to preserve its language and culture through American-born children. (PW.)

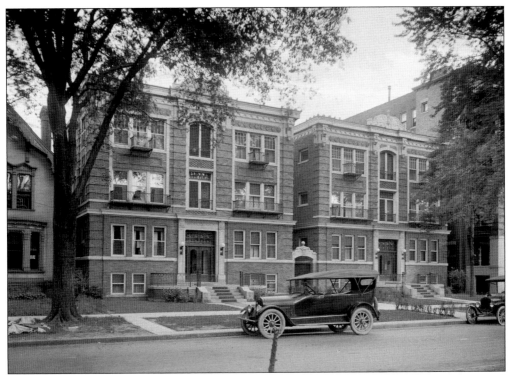

These identical three-story apartment buildings, the Woodstock, were connected by an ornamental stone arch. When they were built in 1914, they attracted a number of business owners and prominent members of Detroit's social elite. Peterboro Street eventually became a part of Chinatown in the 1950s. It later became home to low-income residents who continue to enjoy the beautiful architecture. (LOC.)

Cass Park was undergoing a rapid transformation from being surrounded by stately homes into a commercial and entertainment center in the early 1920s. This image shows the houses that were soon to be demolished on the west side of the park. They would be replaced by the national headquarters of the S.S. Kresge Company. (PW.)

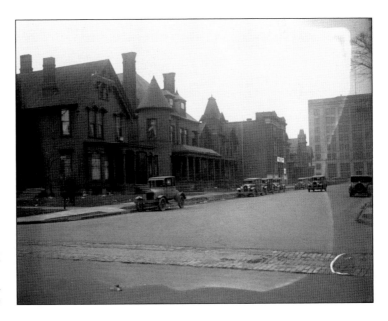

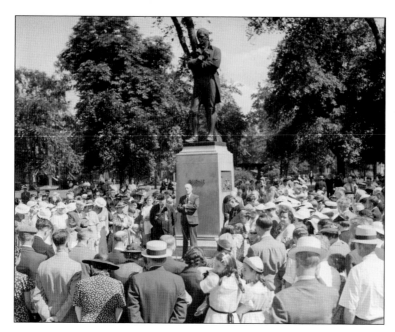

The statue of Robert Burns is shown here at the 1921 dedication ceremony for the favorite poet of Scotland—ancestral home of many of the Cass Corridor's inhabitants at the time. The statue still stands at the northern end of the park. (RL.)

These two apartment buildings were constructed in the 1920s to house middle-class people who would appreciate beautiful design. The Edman, on the right, incorporates balconies in the second- and third-floor front apartments. The Milton Apartments, next door to the left, is also a stately structure. Both buildings have been restored by Bob Slattery, who is one of the earliest developers in the Cass Corridor. (AD.)

Built shortly before the advent of the automobile, the Second Avenue Terrace contained nine dwellings facing Second Avenue and two facing West Willis Street. It housed prominent citizens, including the architect of the Michigan State Capitol and the editor of the *Detroit Journal*. Like many of the buildings of the Cass Corridor, by the mid-20th century, the structure was subdivided to accommodate the migration of workers to the city. By the 1960s, it was one of the first buildings to be renovated into condominiums. Pictured below is a group of young people working on the restoration of the building in the 1970s. (Both, MS.)

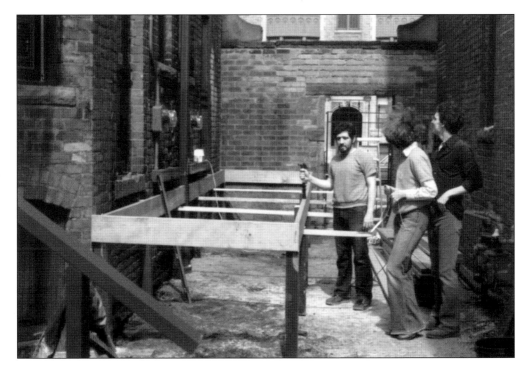

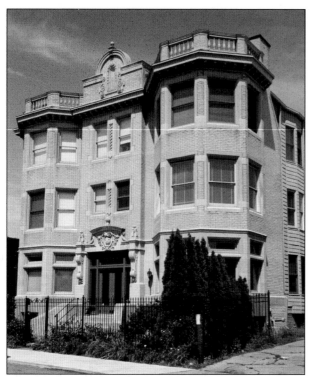

Built in the 1910s, the Waldorf Apartment House originally housed three units, as did each of the two other buildings to its immediate south. Both of the other two were demolished, and the space has been converted to a pleasant garden for residents of the restored units. The Richardsonian Romanesque style of architecture makes this building stand out. (RDR.)

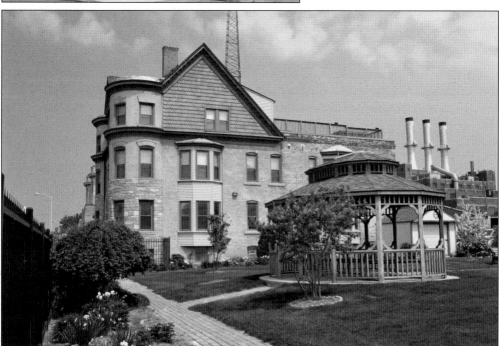

During the early 1900s, the Venn Apartment House was built to accommodate well-to-do tenants. Six, 8-room units with only two units per floor made for spacious and gracious living. By the 1920s, the building had been converted to 12 units to accommodate poorer migrants in the city. It was restored to its original six units and converted into condominiums in the 1980s. (MP.)

While attached houses often referred to as row houses, or in this case, terraces, were common on the east coast, relatively few were built in Michigan. This example of well-preserved terraces on Hancock Street and Third Avenue is outstanding. Built in 1913, it features two-story, rounded bays in each of the eight units. The common areas in the rear are well landscaped and maintained. (EK.)

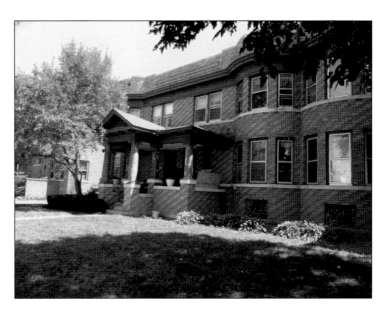

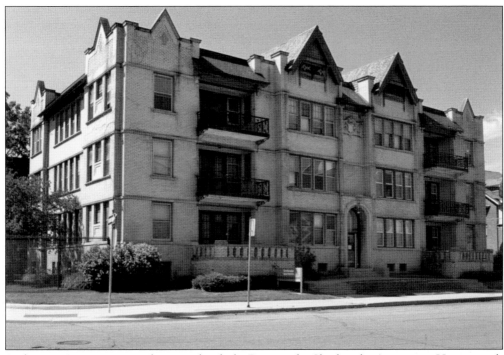

Built in 1913 in a unique architectural style for Detroit, the Sherbrooke Apartment House, south of Wayne State University, stands majestically at the corner of Second Avenue and Hancock Street. Almost alone among Detroit's architecture of the time, it boasted balconies for the upper units and is clad in buff brick. In 2011, the building was emptied so that the current owner could restore and update it as condominiums. (RDR.)

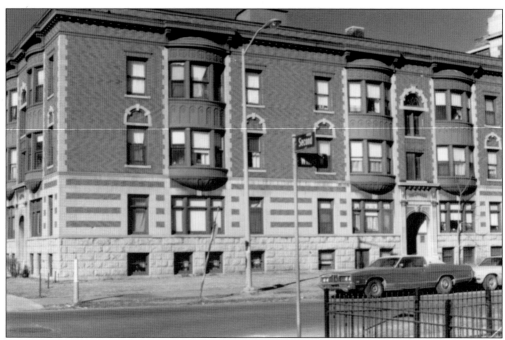

This compact apartment building is a stately presence on Second Avenue and West Willis Street. The Charles was constructed in 1908, when the Cass Corridor was attracting a relatively affluent middle-class population. With some beautiful architectural features, such as bay windows in each apartment and decorative stone banding, it has charmed residents and passersby for over 100 years. (AD.)

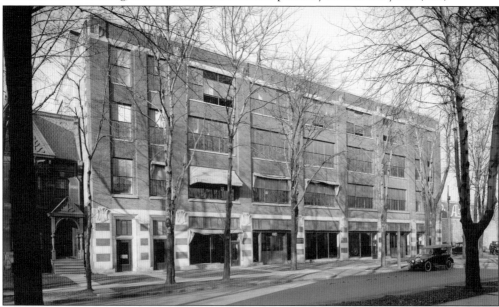

One of the largest commercial buildings to be constructed in the Cass Corridor was this storage facility for the Willys-Knight and Overland Motor Car Company. The company eventually evolved into the Jeep Division of the Chrysler Motor Company. The building was a warehouse from the 1940s until the 2000s, when it was purchased by developers who converted it into loft condominiums with retail space on the ground floor. (WO.)

Not all of the industries located in the Cass Corridor were automobile-related. Kanners and Co. opened in what is now the Green Garage in 1941. The company repaired and sold shoes, wholesale and retail. Their motto was "You'll like to deal with Kanners." The company was sold to the Patrize family in 1976, and the building has since been renovated. (JL.)

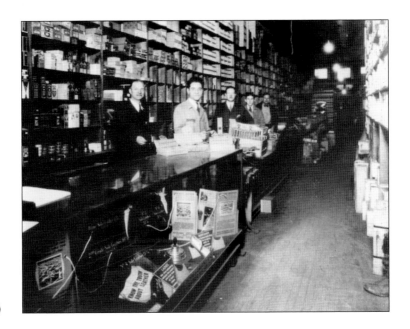

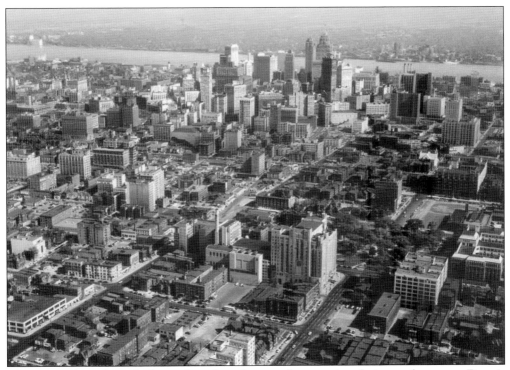

This image shows how the lower Cass Corridor was changing in relation to downtown Detroit in the distance. By 1935, the downtown commercial center seemed about to absorb the formerly residential community. (RL.)

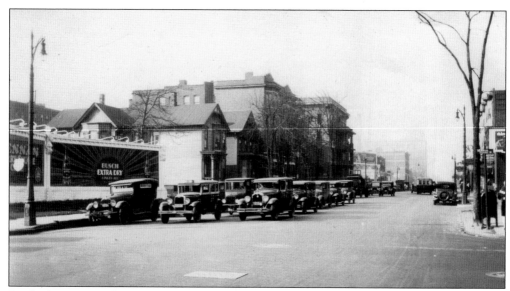

By the late 1920s, the character of the lower Cass Corridor had changed. No longer a quiet residential neighborhood, the large apartment buildings and commercial enterprises resulted in heavy traffic. A changing demographic that included many working-class and poor people was the result. (PW.)

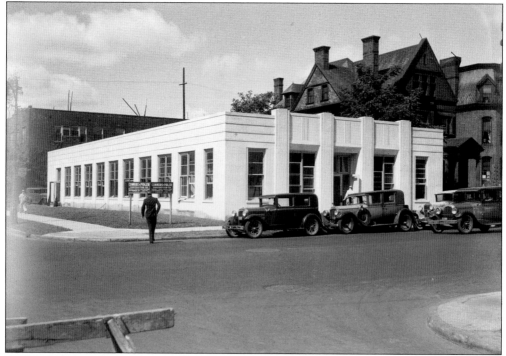

Sophia Siegel, widow of the founder of women's clothing chain B. Siegel's, had this building constructed as a rental property. One of a small number of Art Deco–styled buildings in the Cass Corridor, it was first occupied by the Michigan secretary of state's offices in 1935. Shortly after, it was occupied by the Hudson Manufacturing Company. In 2011, it was transformed into the catering division of Slows Barbeque. (RDR.)

Typical of neighborhood commercial buildings erected in Detroit during the 1920s, this structure housed a drugstore in 1928 in the corner storefront. Offices occupied the second floor for many years. The simple architecture included some pleasant appointments, including a curved corner and decorative brickwork. In 1986, it became the home of the Islamic Center of Detroit, serving many of the international students at the nearby university, as well as other Americans. (RDR.)

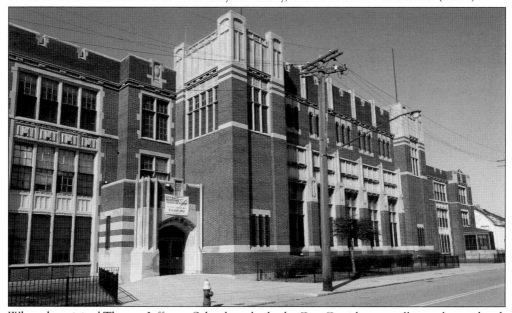

When the original Thomas Jefferson School was built, the Cass Corridor was still sparsely populated. By the 1920s, a new school was desperately needed, so the board of education decided to relocate the school to Selden Street, where it became the Jefferson Intermediate School. The architectural style chosen was Collegiate Gothic, a style very popular on college campuses at the time. The school closed during the 1970s but was restored as a charter school in the 1990s. (MP.)

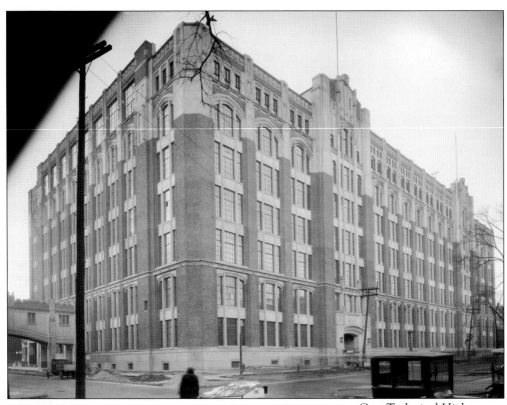

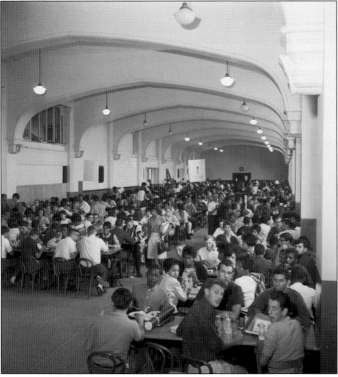

Cass Technical High School has been a nationally recognized center of education for most of its existence. It was a pioneer in vocational education and a leader in fine-arts education. Many of its graduates have become local and national leaders in the arts, sciences, and politics. Its eight stories included a 3,000-seat auditorium, shops, laboratories, and other innovations. The lunchroom pictured at left served up to 1,000 students at a time. It has been demolished. (Both, RL.)

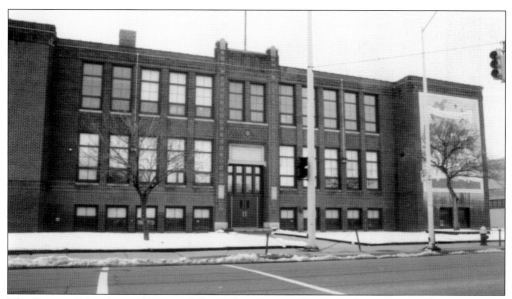

The Burton School initially served the well-to-do population of the southern part of the Cass Corridor and transitioned along with the rest of the neighborhood during and after the Depression of the 1930s. In the 1950s, when Chinatown relocated along Cass Avenue, it was informally known as "the Chinese school." Today, it has been transformed into a center for the arts by its owner, Joel Landy. (MP.)

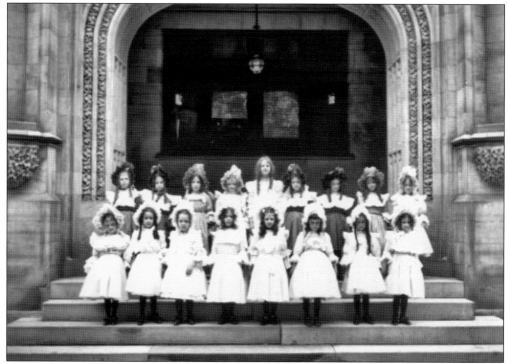

St. Peter and Paul School was the only Catholic institution in the largely Protestant community. These girls posed for a group picture celebrating their First Holy Communion in 1895. Today, the building, located on Parsons Street, is known as the St. Patrick Senior Citizen Center. (PW.)

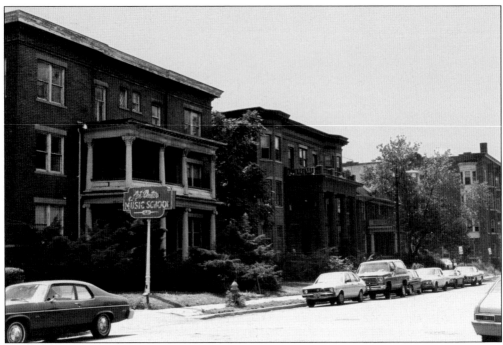

Hancock Street was the southern limit of Wayne State University's main campus. The south side of the street was residential and home to the Art Center Music School of Detroit. The music school occupied a former mansion that, like many of the old homes in the Cass Corridor, had been repurposed during the mid-20th century. The image above, looking west toward Second Avenue, was taken in the 1950s. At the end of the block is the Renaud apartment house. It is still in use, but the music school was demolished in the 1980s to make way for new condominiums. In the image below is the First Church of Christ Scientist located east of the Art Center Music School. It was sold to Wayne State University in the 1960s and transformed into the Hilberry Theatre. It has been home to the drama graduate program ever since. (Both, PW.)

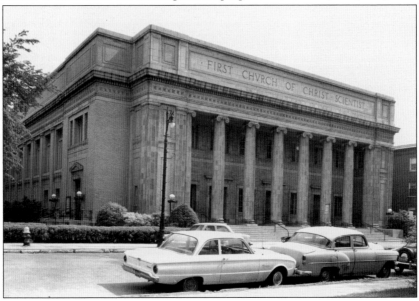

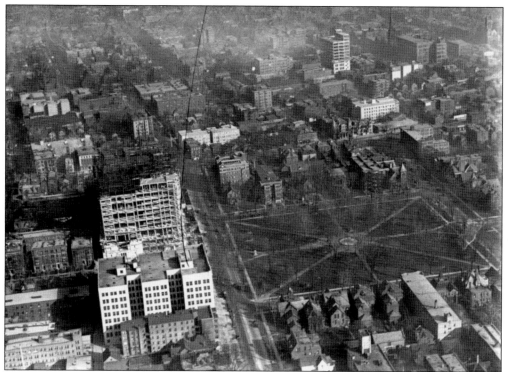

By the 1920s, the Cass Corridor was being transformed from an upper-class residential community into a commercial and entertainment center. This view of Cass Park shows the construction of the Masonic temple, with many individual houses still intact. Very few of the houses have survived in the 21st century. (RL.)

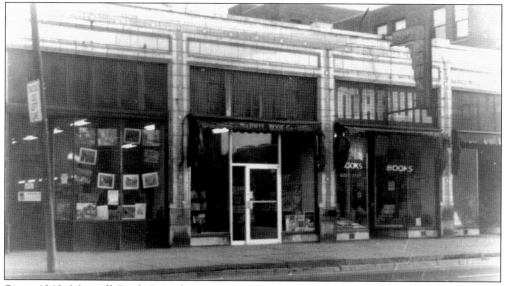

Since 1948, Marwell Book Store has served students of Wayne State University and residents of the Cass Corridor. When the above location was condemned by the city, the bookstore was moved to the corner of Warren and Cass Avenues. It is one of a very small number of independent bookstores in southeastern Michigan. (MJ.)

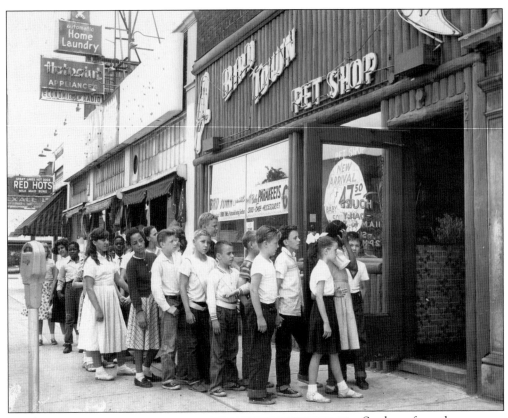

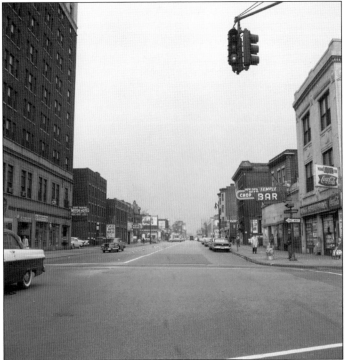

Students from the nearby Burton School lined up to visit the Bird Town Pet Shop on Cass Avenue in the 1950s. The students reflect the growing diversity in the area. Within a few years, Detroit's Chinatown would relocate one block south, and the Burton School became known as "the Chinese school" for a time. (BT.)

This 1950s view looks north on Cass Avenue from the intersection of Temple Street. While many of the buildings are still standing, most of them are no longer in use. A notable exception is the Temple Bar at right. (RL.)

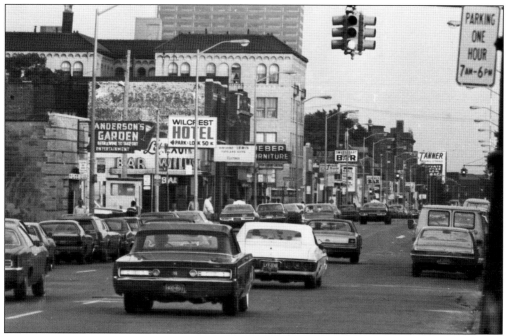

Up through the 1960s, Third Avenue was a bustling thoroughfare. This picture is of Third Avenue, looking south from West Canfield Street. The various bars and stores catered not only to the local population but also to transient people heading to downtown Detroit. A number of the businesses, such as Anderson's Garden and the Willis Show Bar at left, were well known to the Detroit police. (PW.)

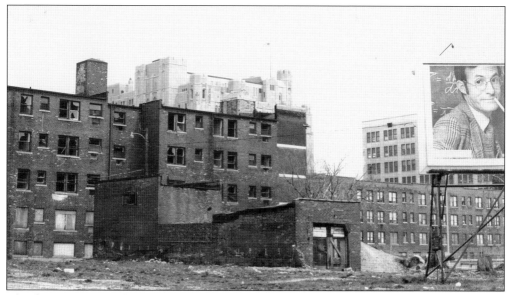

The deterioration of the Cass Corridor, especially in the south end, is reflected in this picture taken in 1970. In the background is a side view of the top of the Masonic temple. The billboard at right seems to reflect the sad state of the abandonment below. (GV.)

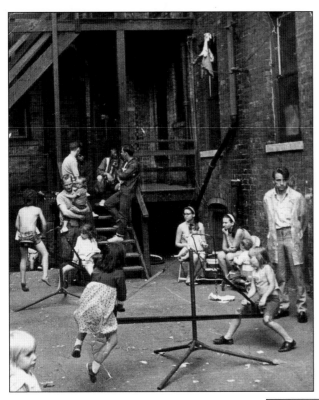

During the Great Depression, the Cass Corridor lost many of its middle-class residents and was repopulated by the poor. Reflecting the segregated nature of the city at the time, the white Appalachian migrants tended to live west of Woodward Avenue in the Cass Corridor, while the African American migrants populated the east side of Woodward. The people shown here lived off Second Avenue in apartments originally built for wealthy tenants but that had been subdivided for the poor. (RBR.)

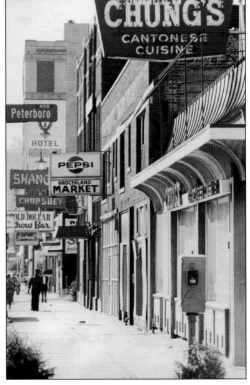

Detroit's Chinatown, originally located adjacent to Corktown, was demolished to build the Lodge Freeway in the 1950s. The community decided to relocate to Cass Avenue north of Temple Street. This scene, looking south along Cass Avenue, shows the diversity of people and businesses along the street. Chung's, the Gold Dollar Show Bar, and the Americana Hotel in the distance are no longer operating. (DN.)

Three

CULTURE
AND ENTERTAINMENT

The transformation of the Cass Corridor during the amazing growth of Detroit in the 20th century resulted in a metamorphosis from a quiet upper-class community of residences and churches into an urban hub of commerce and entertainment. The city's maturity from provincial outpost into a sophisticated urban center resulted in the development of a number of cultural institutions, as well as some more popular entertainment centers.

The 1919 construction of Detroit's symphony auditorium (Orchestra Hall on Woodward Avenue) was followed by a number of other icons of western culture. The Masonic Temple, constructed on the northern edge of Cass Park, was dedicated in 1926. It was balanced at the northern end of the neighborhood by the 1921 opening of the magnificent main branch of the Detroit Public Library on Woodward Avenue, across from the world-class Detroit Institute of Arts, which was dedicated in 1927. Wayne State University became a college in 1923 and has dominated the northern end of the neighborhood as it has grown.

Meanwhile, more pedestrian entertainment venues that would become beacons to residents of the region were opening throughout the neighborhood. During Prohibition, the area had its share of blind pigs and illegal activities. Following the repeal of Prohibition, in 1933, a number of them became legal. The reopened bars were joined by restaurants, movie theaters, dance halls, and roller-skating rinks.

The Cass Corridor had become the cultural and entertainment center of Detroit.

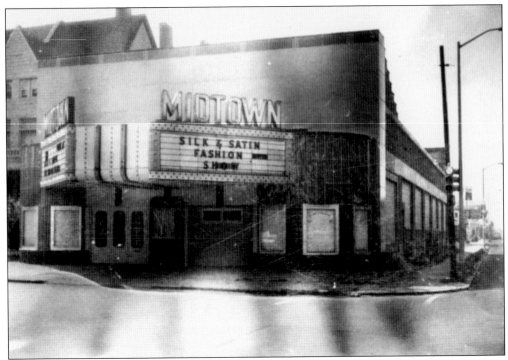

This building anchors the south side of historical Canfield Street off of Third Avenue. Built in 1921 and used as a Cadillac service garage through the 1930s, this building was converted into the Midtown Theater, pictured here, in 1940 and was used as such for 25 years. In the mid-1960s, the building was re-adapted once again for its present tenant—the church of the Brown Evangelistic Ministries. (PW.)

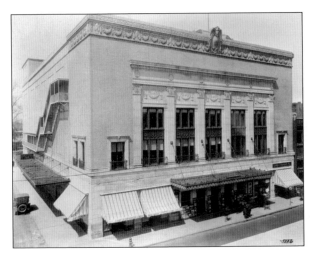

As industry boomed and wealth increased in the early 20th century, Detroit strove to develop its cultural icons. In 1919, Orchestra Hall, a magnificent hall with almost perfect acoustics, was built. The orchestra moved in 1939, and the hall became the Paradise Theater, specializing in movies, vaudeville, and jazz. Abandoned in the 1950s, a group of musicians and others saved the hall from demolition in the late 1970s. The Detroit Symphony Orchestra returned to the hall in 1984, where they continue to make beautiful music today. (JL.)

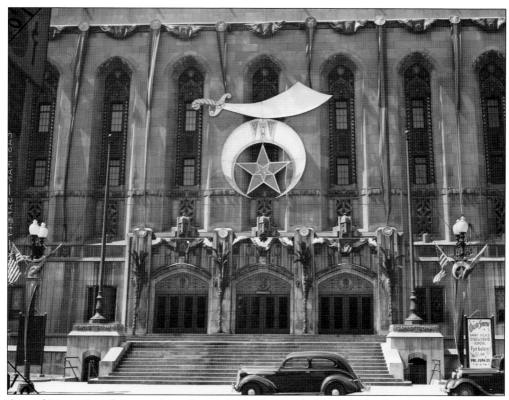

One of Detroit's architectural jewels, the Masonic temple is reputed to be the largest Masonic temple in the world. The complex is adorned by awesome architectural sculptures, inside and out, designed by famed Detroit artist Corrado Parducci. The auditorium seats close to 5,000 people and has been the scene of many cultural events in the city, including the Detroit Symphony Orchestra and the touring Metropolitan Opera Company. (RDR.)

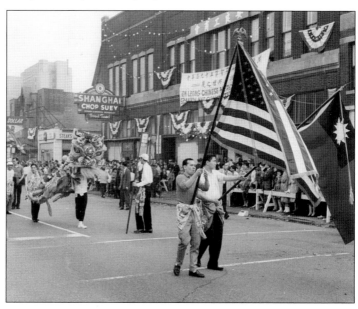

During the 1960s, Cass Avenue was the main street for Detroit's Chinese community. This parade celebrating a Chinese holiday attracted a large crowd. In the distance is the back of the Masonic Temple. (RL.)

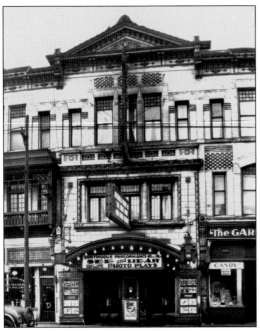

C. Howard Crane was a Detroit architect who designed hundreds of movie theaters across America. The Garden Theater was a relatively small 900-seat auditorium located on Woodward Avenue, one block north of Orchestra Hall. In addition to the theater, there were commercial storefronts. By the 1950s, with the proliferation of television, the theater was closed. It reopened during the 1960s, showing adult movies, but it was eventually abandoned. (JL.)

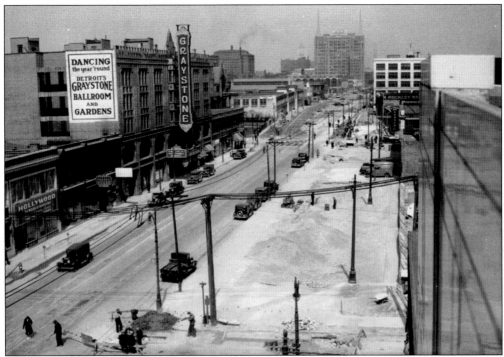

From the 1920s until the 1950s, jazz and big bands were very popular. A number of dance halls sprung up along Woodward Avenue in Detroit, and the Graystone Ballroom was one of the most popular. Glenn Miller, the Dorseys, Guy Lombardo, Cab Calloway, and most of the popular bands in the country played at the Graystone during its heyday. By the 1970s, the Graystone was abandoned and demolished, replaced with a fast-food restaurant, which was also demolished after only a few years of existence. Now the location is a vacant lot. (RL.)

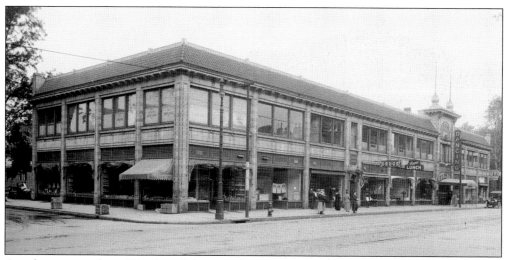

Another venue along Woodward Avenue that provided Detroiters with entertainment was the Arcadia Ballroom. For a time, a number of other entertainment establishments, known as "dime-a-dance" ballrooms, existed in this building and others along the street. This building was later transformed into a roller-skating rink, but it was eventually demolished in order to widen Martin Luther King Boulevard in the 1970s. (RL.)

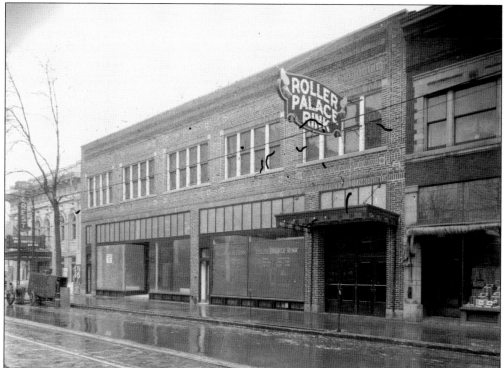

While many of the commercial establishments in the Cass Corridor were automobile-related, the stores on Woodward Avenue specialized in entertainment. Orchestra Hall and the Graystone Ballroom represented the high arts, while places like the Roller Palace Rink at Woodward and Forest Avenues were plain entertainment. The Roller Palace, where young people could meet and mingle, attracted crowds until the 1950s. (RL.)

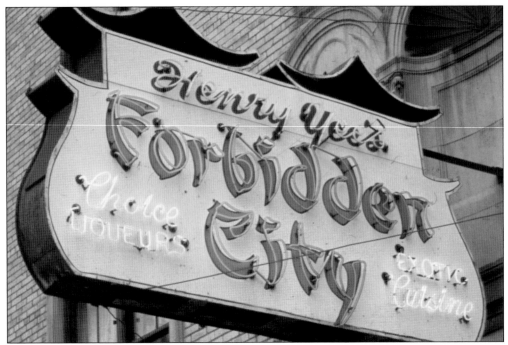

With the destruction of Detroit's original Chinatown for highway construction in the 1950s, the community relocated to the southern end of the Cass Corridor. Centering on the corner of Cass Avenue and Peterboro Street, Chinatown consisted of a number of restaurants and stores that served the Chinese community, as well as the community at large. Henry Yee's Forbidden City, a very popular restaurant, was located in the Seville Hotel around the corner on Second Avenue. (RL.)

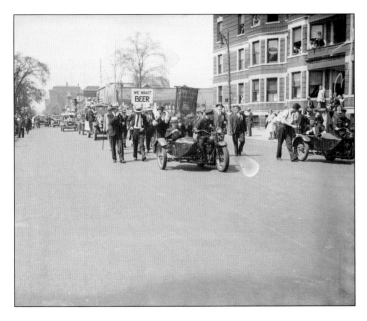

The Cass Corridor, like all of America, experienced some frustration during the 13 years of Prohibition. Even those who disapproved of alcohol use eventually tired of the social problems involved with Prohibition. In 1933, this large parade included many strata of Detroit society protesting the effects of Prohibition on the city and the nation. Mackenzie Hall is in the background as the paraders marched south on Cass Avenue toward downtown Detroit. (RL.)

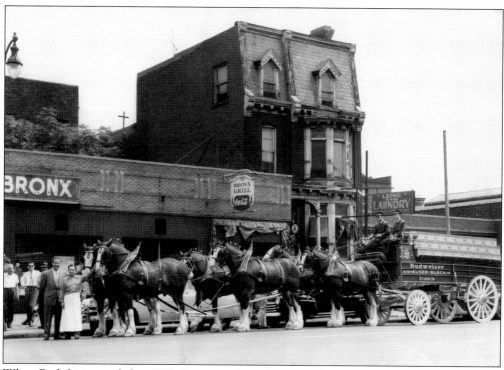

When Prohibition ended in 1933, Detroiters happily returned to legal saloons and beer gardens. Once again, the Budweiser Company began to sell its products across the country. The company's iconic Clydesdale horses made appearances in a number of venues in Detroit, such as this promotional event in front of the Bronx Grill on Second Avenue in the 1950s. The bar remains a popular watering hole today. (BB.)

The Cass Corridor has been a center of entertainment during most of the 20th century. The variety of venues reflects the diversity in the Cass Corridor and the city of Detroit. Shown here are entertainers belting out a song at Buddy and Jimmy's, a popular bar, in the 1950s. Located on Cass Avenue, Buddy and Jimmy's provided food, drink, and entertainment well into the 1960s. (PW.)

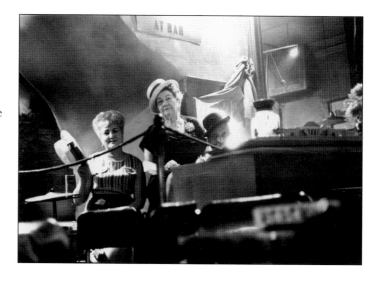

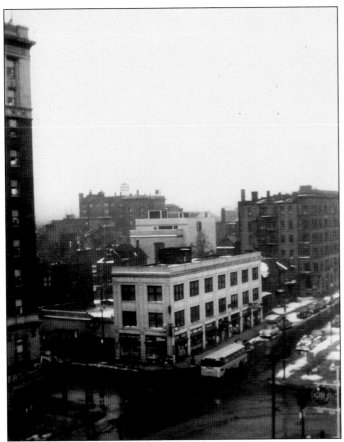

The Temple Bar, shown to the left of the three-story building that sits at the intersection of Cass Avenue and Temple Street, has been an anchor of the Cass Park area since the 1920s. Built in 1925, it was originally a grocery store, restaurant, and shoe repair business. After the repeal of Prohibition, the building became home to the Temple Bar. The interior looks much as it did when it opened, and the scene below, captured in the 1940s, is the same today. The bartender shown here is Gust Boukas, father of the current owner, George Boukas. (Both, GB.)

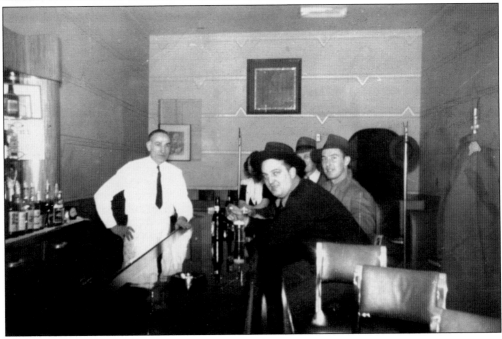

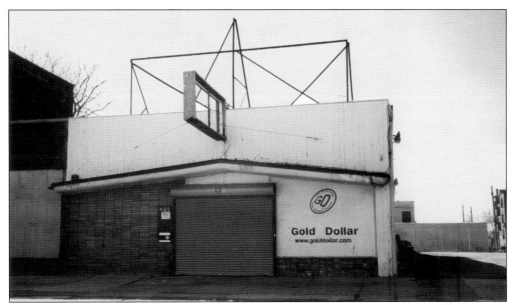

With the end of Prohibition, many of the underground saloons became legal and continued to serve as entertainment centers. The Cass Corridor was an important center for these establishments, both along the city's main street, Woodward Avenue, and the other streets. The Gold Dollar became known as a site for female impersonators during the 1950s and was later home to the city's robust garage rock bands in the 1980s and 1990s. It awaits a further transition in 2011. (AD.)

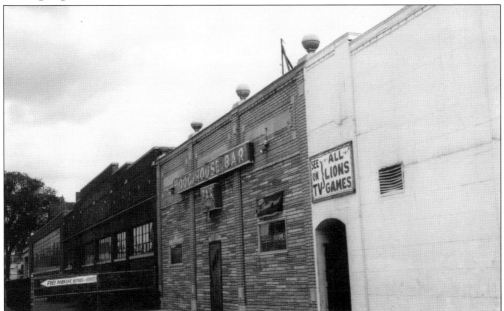

In 1924, this building was constructed at the corner of Second Avenue and West Canfield Street to serve the growing population of the area. It was home to the Palm Garden Restaurant initially, and after a short time, the Honey Bee Restaurant was located in the building. During the Depression, the building housed a grocery store, and with the end of Prohibition, it became the Dog House Bar. In the 1960s, the building became the Traffic Jam and Snug and has remained a popular restaurant for people from throughout the Detroit area. (SL.)

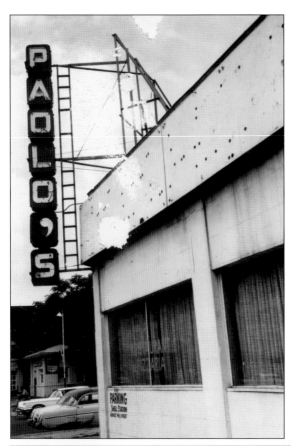

Being close to Wayne State University meant that there were thousands of students and staff nearby. Most of them were commuters who would stop for lunch, dinner, or a snack after classes. The corner of West Canfield and Second Avenue was home to the popular Paolo's Pizza from the 1940s until the 1960s. It was incorporated into the Traffic Jam and Snug when that restaurant opened in 1966. (SL.)

The Traffic Jam and Snug became an instant hit with the students from nearby Wayne State University. The picture below, taken in 1966, shows a crowd of young people, mostly students, enjoying an evening of relaxation. Notice the table on the left; its top is a slice of tree trunk, as were all the tabletops. (RL.)

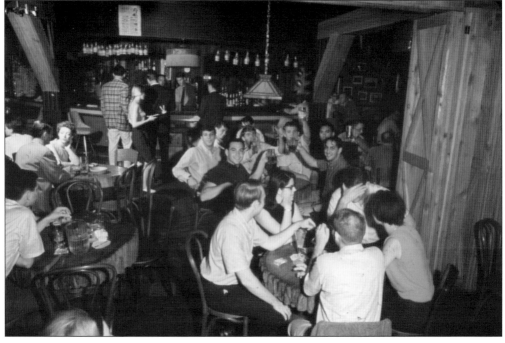

Four

ART AND REVOLUTION

By the 1950s, Detroit had recovered from the Great Depression and World War II and was reveling in its newly recovered prosperity. While the middle classes were upwardly mobile and using their newfound wealth to move to the suburbs, the Cass Corridor was becoming more and more the home of the poor and the dispossessed. Most of the beautiful houses and apartments that had been home to the prosperous gentry of the 19th century and early automobile magnates were subdivided into rooming houses and small apartments. A gritty feel permeated the area, which had once been the envy of the working class that now shunned it. Even the cultural gems that had characterized the fringes of the area were falling into decay.

Despite the changes, or perhaps because of them, the Cass Corridor became the center of a tremendous surge of creativity during the decades of the 1960s and 1970s. With Wayne State University to the north, the Detroit Institute of Arts and the Society for the Arts and Crafts to the east, the low rents, and a population that was indifferent to the countercultural ways of the artists and musicians that settled in the neighborhood, the Cass Corridor area naturally lured an interesting crowd.

Serendipity meant that a number of creative people and organizations arrived and encouraged each other in their quest to understand the changing industrial environment of Detroit. These residents looked to bring about social justice, an end to military aggression (especially in Vietnam), and encourage personal freedom without the inhibitions of a restrictive society. The concentration of creative geniuses along and off Cass Avenue has left a legacy that, in many ways, has given the Cass Corridor a reputation of being Detroit's intellectual and creative center.

Many of the individuals who were the movers and shakers of the era ultimately became national figures in social movements and the arts.

While some of the venues that gave the corridor its flavor in the 1960s and 1970s have disappeared or changed, the legacy lives on in the many cultural and creative institutions and individuals still located in the Cass Corridor.

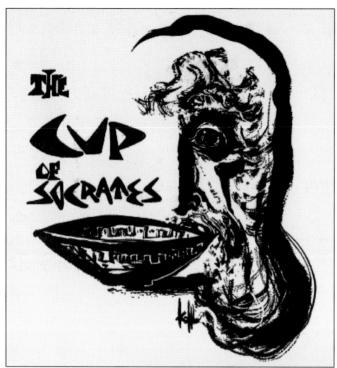

One of the first signs of the developing bohemian nature of the Cass Corridor occurred in the 1950s. The Cup of Socrates was probably the first European-style coffeehouse in the Detroit area that served espresso coffee and featured folk musicians and poetry readings. Pictured at left is the logo from its menu. The coffeehouse closed after a few years, but it foreshadowed a new era for the Cass Corridor. (PW.)

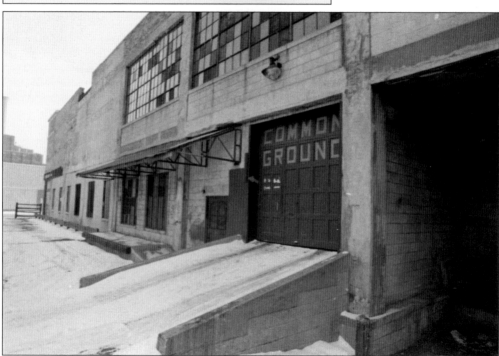

The Common Ground of the Arts was created in 1963 to provide Detroit artists with a place to create and exchange ideas and support each other. A distinct artistic movement in Detroit had begun. The Common Ground created a sense of mutual respect and encouragement for the young artists who populated the Cass Corridor at that time. (RL.)

68

This poster from May 1969 promoted a group show at the Detroit Artists Market, a gallery that promoted local artists. The 18-artist group show was another example of the advantages the Cass Corridor artists shared; they supported each other in many ways. Many of these artists went on to national and international acclaim. Their loyalty to each other is demonstrated by the fact that they maintain contact up to the present day. (SD.)

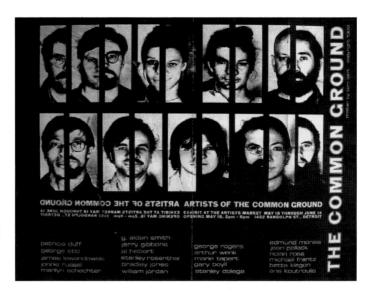

With the onset of the 1960s, the Cass Corridor became the epicenter of a culture composed of young people, artists, and social activists who gathered to encourage each other and the society at large to open up, reject the conformism of the 1950s, and embrace a new world. A number of gathering places encouraged the cross fertilization of ideas and creativity. Perhaps the prototype was Cobb's Corner, a bar and gathering place for the artists and activists. Herb Normile, the bar's owner, created that atmosphere. (RL.)

In the same building as Cobb's Corner, gallery space was rented to artists from the neighborhood for little cost. Pictured here is Arthur Wenk on Willis Street next to his wooden sculpture. The Willis Gallery was a cooperative run by the artists themselves and reflecting the philosophy that most of the artists professed. (RL.)

The interior of the Willis Gallery consisted of a concrete floor with white walls. The art itself would attract the visitor's attention. Pictured here at an early show at the gallery are, from left to right, artists Bradley Jones, Ellen Phelan, Ron Winokur, Nancy Mitchnick, and Douglas James. They have all been recognized for their creativity and talent. (RL.)

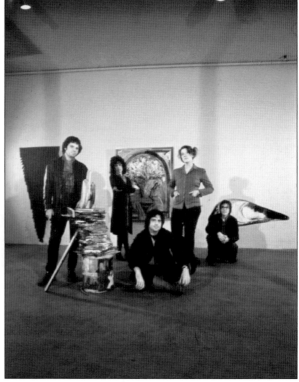

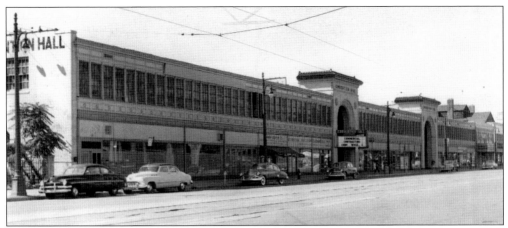

When the new Cobo Hall opened in the Detroit Civic Center in 1961, the old Convention Hall on Cass Avenue was vacated. This presented an opportunity for the growing art community to have a large space available for studios. By the late 1960s, Convention Hall was home to many local artists. Its location, one block north of the Common Ground of the Arts, made it convenient for artists to exchange ideas and to offer support to one another. (BH.)

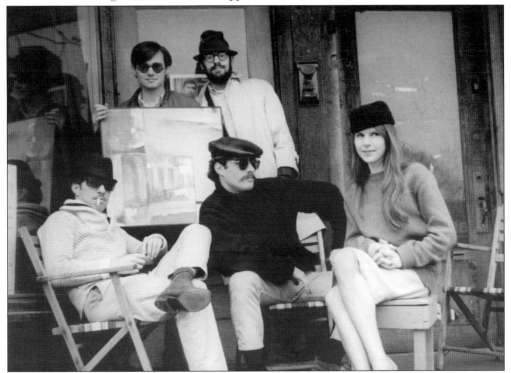

In 1964, several musicians, artists, poets, and students from the Montieth College at Wayne State University established the Detroit Artists Workshop. They sought to create an atmosphere in the city that would be the center of a cultural and social revolution in Detroit, the United States, and the world. They found a house near the campus, which they rented and turned into their headquarters. The energy attracted many young people to their countercultural lifestyle, but it also attracted the police. Seen here are, from left to right, (first row) Robert Winters, Robin Eichele, and Marty Allgire; (second row) George Tysh and Alan Stone. (LS.)

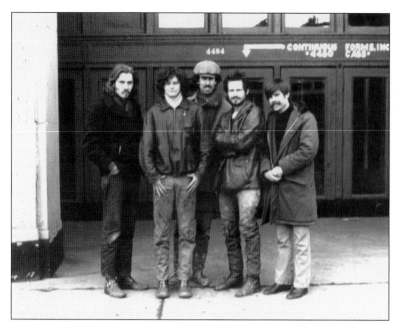

Among the artists who had studios and/or lived in the Convention Hall were the five pictured here. They are, from left to right, John Agner, Gordon Newton, Bob Sestok, Michael Lukes, and Jay Shirley. They have all made contributions to Detroit's artistic legacy and have become renowned in the art world. (RV.)

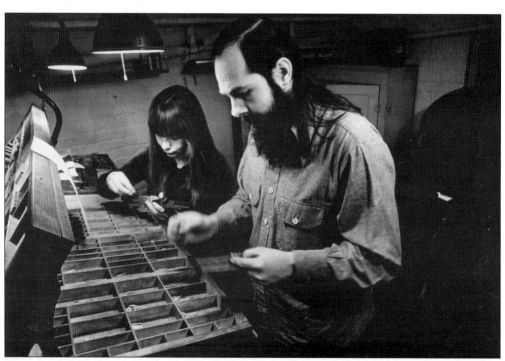

Two people who epitomize the spirit of the Cass Corridor in the 1960s and 1970s were Ken and Ann Mikolowski. He is a poet and she an artist. Part of the original artists' workshop, they managed to provide encouragement and inspiration to the many other activists and creative people in the neighborhood. This photograph, taken in 1971, shows them typesetting their press. Their generosity of spirit is still remembered by their colleagues many years later. (KM.)

Bradley Jones (left) and Edward Levine were active participants in the art and antiwar scene in the Cass Corridor during the 1960s and 1970s. Jones produced art at both the Convention Hall and the Common Ground and participated in many group shows. Levine moved on but returned to his art after a short business career. Jones died at a very young age and is sorely missed by everyone who knew him. (SD.)

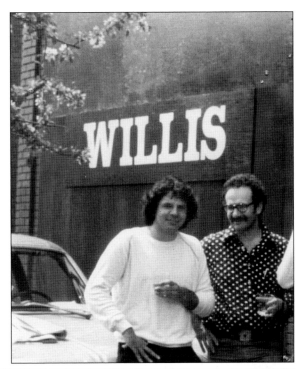

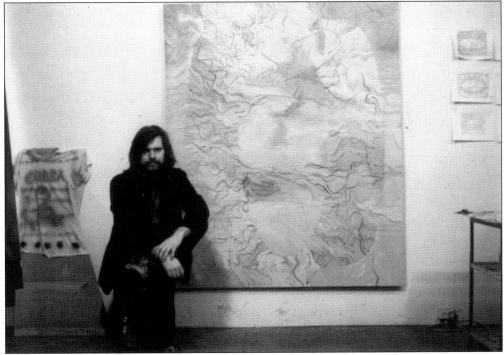

One of the younger members of the Cass Corridor artistic society was Rick Vian. Pictured above in his studio in the early 1970s, he participated in a number of exhibits at the various galleries of the area—the Willis, the Forsythe, and the Detroit Artists Market, to name a few. Like many artists from the era, he has continued to produce and exhibit art throughout Michigan. (RV.)

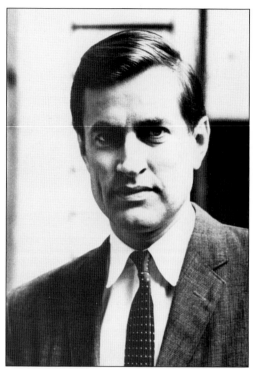

Samuel J. Wagstaff served as the curator of contemporary art at the Detroit Institute of Arts from 1968 until 1971. During his tenure in Detroit, he became one of the strongest supporters of local artists. As the curator of modern art, he guided the museum in the direction of supporting local artists and encouraging the new approaches that artists were forging. He encouraged local collectors to support hometown artists and introduced those artists to the national scene in New York City. (DIA.)

Throughout history, artists have depended on patrons who encourage them, help them to connect with collectors and curators, and even support them financially when necessary. Pictured below are two of the Cass Corridor artists' major supporters, James Duffy and Suzanne Hilberry. Duffy owned an industrial enterprise but was also an art collector and dedicated supporter. An early supporter of local artists, Hilberry has continued to be a patron of the arts. (RS.)

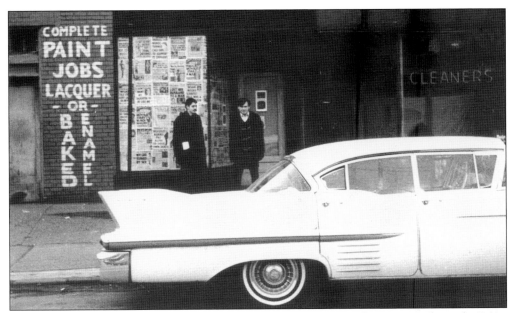

Two young artists stand in front of the Red Door Gallery on Second Avenue in the early 1960s. The newspaper-covered windows are reflective of the artists' philosophy of taking art into the real world and away from the formal galleries. The Cadillac at the curb represents the wealthy collectors who would still be welcome to purchase the people's art. (RS.)

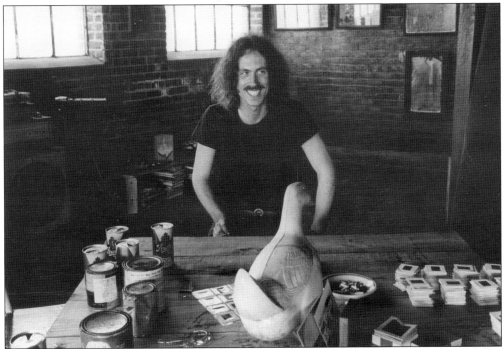

The Forsythe Building, a former factory at the northwest edge of the Cass Corridor, was the site of a number of young artists' studios in the early 1970s. The camaraderie and cheap rent combined to attract them, despite the long walk to the corner of Cass Avenue and Willis Street. In this photograph, Bob Sestok reviews slides of his work as he contemplates a gallery show. (RS.)

The traditional romantic vision of the young artist struggling to support himself or herself while producing art was born out with Cass Corridor artists. Pictured is another artist's studio off an alley. The truck was shared by many of the young artists in hauling found materials that were used in their creations. (RS.)

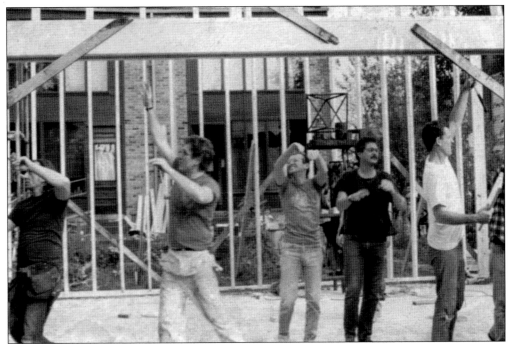

The collaboration of artists extended beyond the exchange of ideas. Fast friendships developed, many of which have endured for decades. Pictured above is a group of artists during a studio raising on West Willis Street; artist Bob Sestok's studio was being built in the rear of his restored house in 1986 by a group of his friends. Below is the studio (to the right of the sculpture) after many years of use, in 2011. Sestok is one of the artists who has continued to live and work in the Cass Corridor. (Both, RS.)

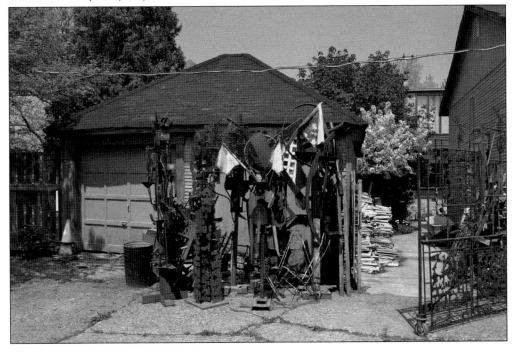

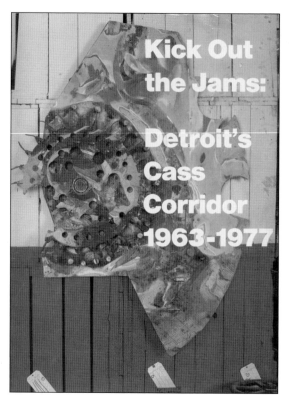

Kick out the Jams: Detroit's Cass Corridor 1963–1977 was the title of an exhibit at the Detroit Institute of Arts presented by Detroit's Cass Corridor artists in 1980. The title refers to a 1969 album by the MC5 that highlighted the important contributions to the art world by Detroit artists of that era. The song "Kick Out the Jams" is a hymn to people who throw off the restraints of convention and create new paradigms. The catalog's cover, seen here, has become a collector's item, and the exhibit is significant in the history of art in Detroit. (AD.)

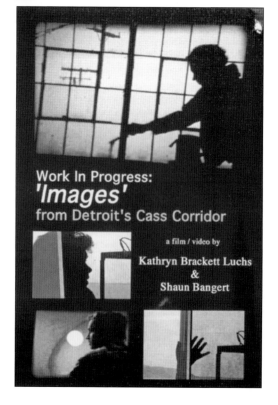

Pictured at right is the poster for the DVD produced by Kathryn Brackett Luchs and Shaun Schwarz about the artists of the Cass Corridor. Luchs grew up in the area and made a number of eight-millimeter films of the artists in the 1970s. Years later, she reinterviewed most of the artists and made this DVD in order to preserve the history of the artistic movement. As a result, future generations will have access to information about the artists and their art during the late 20th century. (RS.)

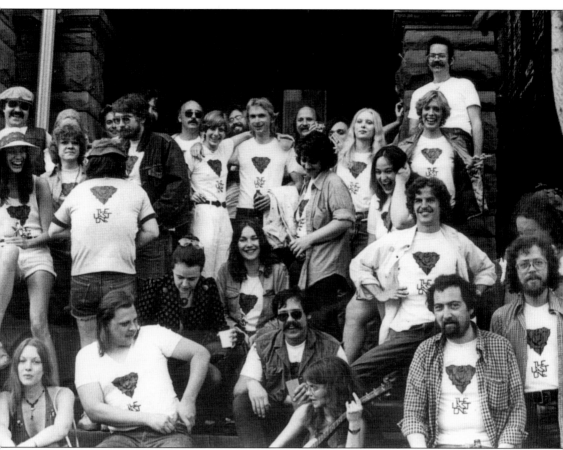

The friendships formed by the artists, poets, photographers, musicians, writers, and their supporters led to many social events over the years. The so-called "House on Second" was a popular meeting place for years, with an annual barbecue referred to as "the annual Attila the Hun barbeque." Many people claim that the Dally in the Alley street festival grew out of this group. (RV.)

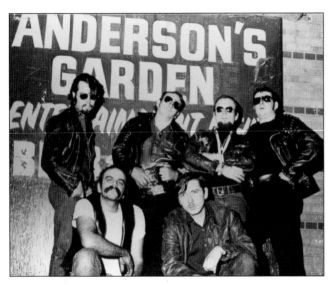

While the Cass Corridor artists and activists have drawn much attention, the music scene was also very lively during the 1960s and 1970s. The Lords, pictured before a gig at Anderson's Garden on Third Street, were one of several well-known local bands. They are, from left to right, Kim "Snake" Berg, bass; George "Carlos" Kerby (first row), guitar; Michael Knight, guitar; Jim "Thunder" Thele (first row), drums; Ralph "Speed-o" Koziarski, sax/woodwinds; and Dennis "The Duke" Pruss, vocals. (DP.)

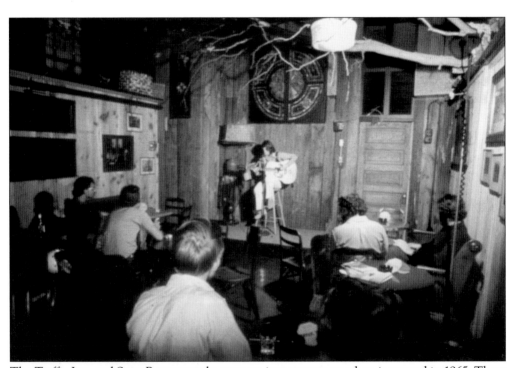

The Traffic Jam and Snug Restaurant became an instant success when it opened in 1965. There were many bars and restaurants nearby, but the relaxed atmosphere and good food attracted a cross-section of the university and neighborhood crowds. Among its many attractions were the tables made from tree trunks. Here, young people are entertained by a folk singer that added to the atmosphere of a neighborhood hangout. (RL.)

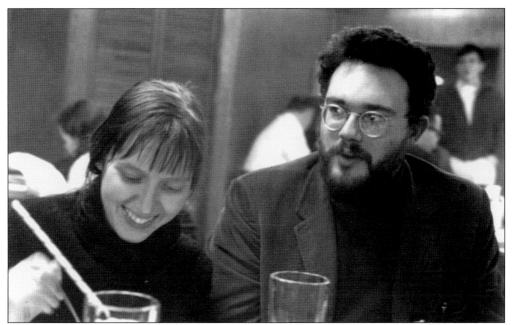

Born and raised in Flint, Michigan, John Sinclair is an icon of the new left in Michigan and the United States. A poet and a political activist, he was a leader of the Detroit Artists Workshop and the White Panther Party during the late 1960s when he also managed the MC5, a rock band. He is pictured above with his wife, Leni, in 1970. His fearless confrontation with the authorities eventually led to his arrest and imprisonment for possessing three marijuana cigarettes in 1969. John Sinclair was released after nationwide protests and a concert featuring John Lennon of the Beatles to raise funds and awareness in Ann Arbor. (RL.)

The *South End*, the student newspaper at Wayne State University, called for students and others to challenge the politics of the 1960s. The editorial policy of giving voice to political alternatives to the war in Vietnam and the civil rights movement led to resistance from some members of the community. This picture was taken in 1967 after a rock had been thrown through the newspaper's window. From left to right, Peter Werbe, Dana Clamage, and an unidentified fellow reporter view the damage. (NM.)

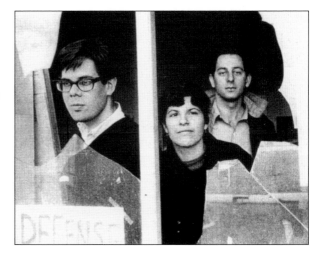

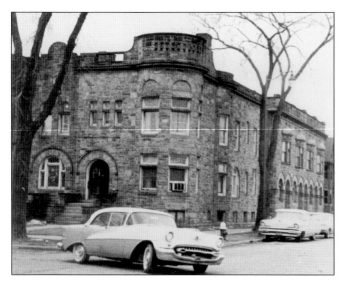

The castle shown at left was home to a number of the members of the artists' workshop. While the activities of the poets, musicians, writers, artists, and revolutionaries were creating an exciting social network in the area surrounding Wayne State University, a number of the individuals moved into this building across the Lodge Expressway from the university. The residents became very active in the antiwar and civil rights movements. This building was demolished in the 1970s. (LS.)

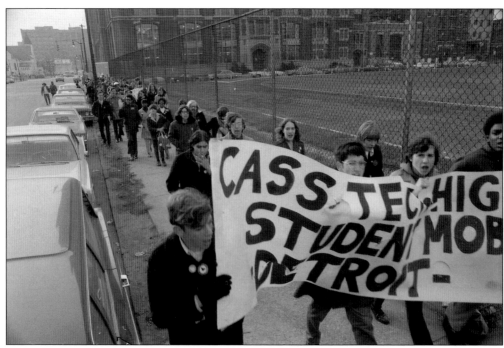

The intense atmosphere that pervaded the Cass Corridor during the civil rights movement and the anti-Vietnam crusade attracted the neighborhood high school students, as well as the university students. This group from Cass Tech High School, located in the south end of the Cass Corridor, marched out of class to protest the nation's involvement in the war. They walked a block to attend a rally in Cass Park in 1969. (RL.)

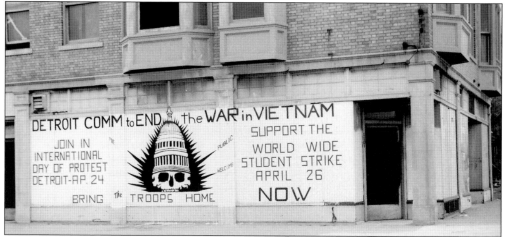

This building at the corner of Warren Avenue and the Lodge Freeway housed a number of politically active people and organizations, including, for a time, the MC5. When the artists' workshop relocated to Ann Arbor, the Detroit Committee to End the War in Vietnam was headquartered here. The building has been demolished and is now the site of a parking lot. (NM.)

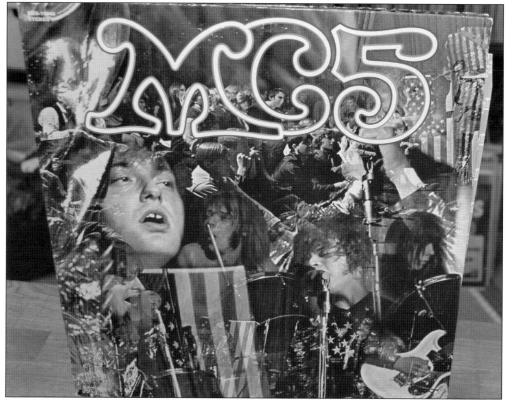

In effect, the MC5 became the unofficial musical favorites of the Cass Corridor arts and revolutionary period. The nationally known group of young musicians called for changing the rules and moving rock music away from the sentimental songs of love and growing up in the 1950s to music that would inspire a revolution in American culture and society. Their first album, *Kick Out the Jams*, became one of the top rock albums of all time. (RDR.)

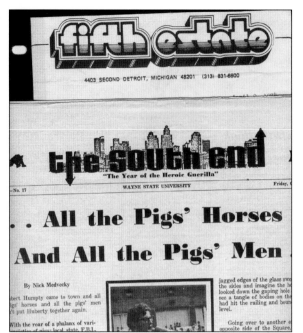

The *Fifth Estate* was founded by 17-year-old student Harvey Ovshinsky in November 1965. It had an antiauthoritarian and nondogmatic orientation that called for radical changes in American society. Over 50 years later, it is still published, though it is no longer in Detroit. The *South End* was the new name for the Wayne State University student newspaper when it began to do political commentary. (NM.)

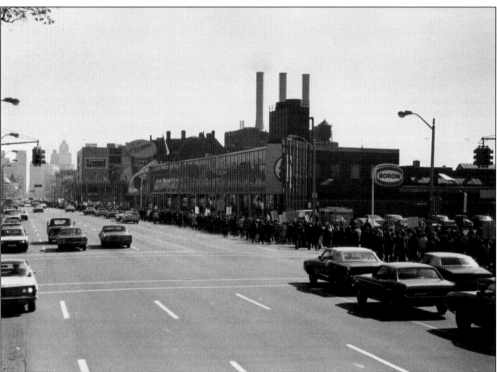

The Wayne State University campus was the epicenter of the antiwar movement during the 1960s and 1970s. Rallies that began on campus would often grow and become demonstrations against the Vietnam War. This march, demanding peace in Vietnam, had a large crowd walking south along Woodward Avenue toward downtown. The crowd is passing the Vernor's Ginger Ale factory (since demolished) located south of Forest Avenue. (NM.)

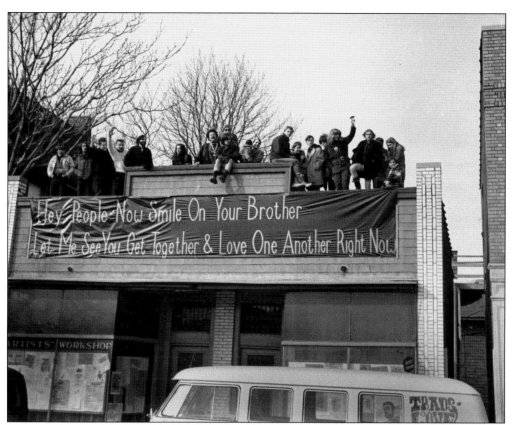

In 1967, the Youngbloods recorded a song entitled "Get Together" that seemed to sum up part of the philosophy of the artists' workshop. This photograph shows workshop members on the roof of their building with some of the words to the song on the banner below them. The words expressed the sentiments of the young activists who hoped to create a kinder, gentler society. (LS.)

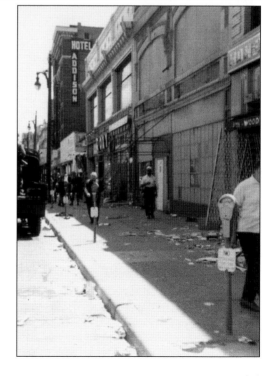

The clamor for change that characterized the late 1960s in America affected Detroit as much, or more, than most other cities. On July 23, 1967, a fight between people being arrested at an after-hours party and the police resulted in several days of rioting, looting, and arson and fierce reaction by the Detroit police. This scene along Woodward Avenue shows broken windows and the results of looting. (NM.)

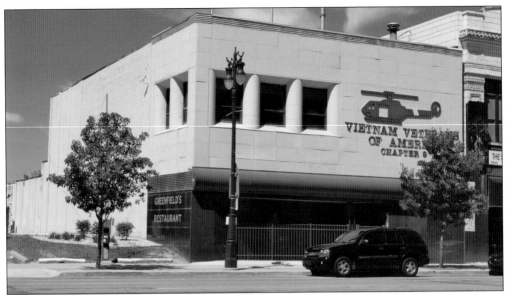

Erected in 1915, this building, like so many of the others in the area, has undergone a number of transformations over the years. Originally housing the Couch Restaurant, the structure became Greenfield's Restaurant soon after. By 1973, the restaurant was sold to the Vietnam Veterans of America. The facade was changed to reflect its new owners, and an image of a helicopter now appears on the upper facade. Coincidentally, the Cass Corridor was home to veterans who had supported the war, as well as the antiwar groups. (RDR.)

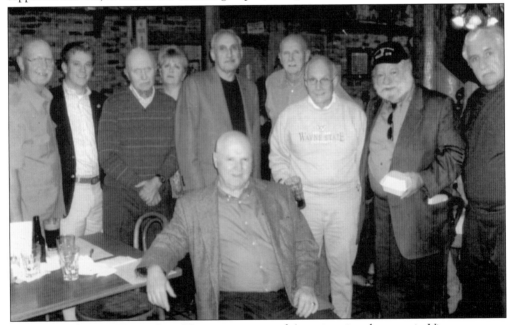

As many students at Wayne State University protested American involvement in Vietnam, many veterans enrolled at the university upon completing their tours of duty. Their presence attested to the diversity of the university community and rounded out the range of opinions that existed in the university setting. The group of veterans pictured above is still active in their veterans' organizations in 2011. (GV.)

Five

TODAY'S CORRIDOR

The imprint of countercultural thought and artistic expression did not fade in the late 1900s, despite increased crime, drug trafficking, and abandonment in the Cass Corridor. This creative spirit doggedly remained in dedicated people and institutions, forming the foundation for the redevelopment of the area that began in earnest at the dawn of the new millennium of the 21st century.

Erasing the past in order to build the future has not been an option in the corridor.

The longevity of landmark bars, restaurants, apartment buildings, houses of worship, and businesses gives the Cass Corridor its character and charisma. These public spaces are animated by welcoming longtime residents whose authenticity makes the neighborhood a haven from competitive, consumer-driven cities and their suburbs.

Today, the corridor's redevelopment is multifaceted and supported by unprecedented collaboration among the surrounding institutions of Wayne State University, the Detroit Medical Center, the museums of the Cultural Center, private foundations, and the public sector. Adaptive reuse of automotive service centers and showrooms into residential lofts has created exciting housing options. New infill housing has been built on vacant land between classic structures, increasing population density and making streets more walkable and enjoyable. Young artists and entrepreneurs are trying their hands at opening coffee shops, microbreweries, gift boutiques, and art galleries. Moreover, existing business and residential owners have reinvested in their properties, modernizing and adapting them for the new era.

Slammed by poverty and decay in the 1970s, the corridor suffered a great deal of disregard and violence. First responders from the 13th precinct and engine house No. 5 were kept busy when Lower Cass was nicknamed "Fire Island" for the number of building fires started by enterprising landlords. (EK.)

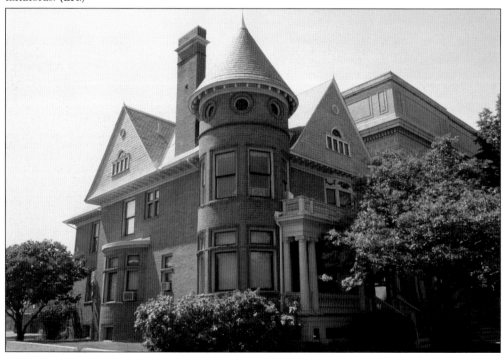

Preservation Wayne, located in the MacKenzie House on Cass Avenue, is Detroit's largest and oldest architectural preservation organization. Started in 1975, partly as a response to the quickly disappearing landscape, it has been instrumental in raising awareness of the corridor's rich architectural character. (AMD.)

By the 1930s, the effects of the Great Depression were being felt throughout the state of Michigan. The Cass Corridor was beginning to reflect the economic and social effects of unemployment and despair. Cass Community Social Services, a branch of Cass Community United Methodist Church (built in 1881 and pictured in the background at right) has been a refuge and beacon of hope for the dispossessed of the area for decades, offering food, shelter, and life-skills training. (EK.)

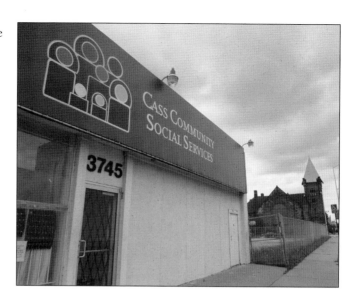

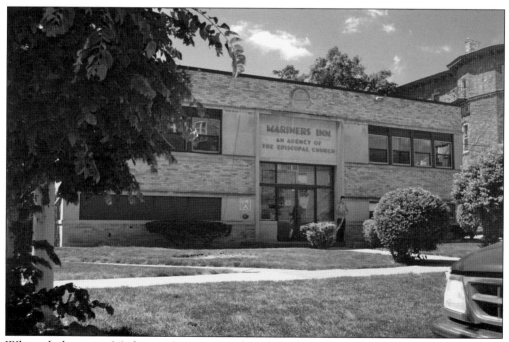

When skid row on Michigan Avenue was demolished, the homeless migrated north to the corridor, and Mariners Inn, pictured here, remains as one of the 65 social service organizations once located in the area. (RDR.)

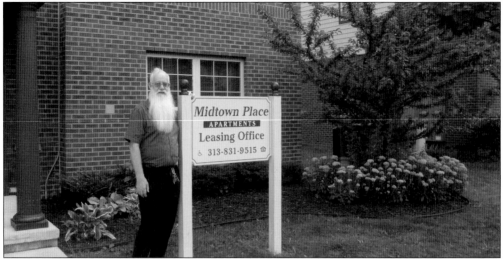

The Cass Corridor Neighborhood Development Corporation (CCNDC) grew out of the Concerned Citizens of Cass Corridor (CCCC) as a response to the growing housing need for lower-income residents. Pat Dorn, pictured, has stood out for decades as a leader of these groups, gathering funds to rehabilitate landmarks like the Chesterfield Apartment House on Cass Avenue and the Architects Building on Brainard Street. Dorn's efforts also include building new housing, such as the $18 million Midtown Place Apartments on Brainard Street constructed in 2005. (EK.)

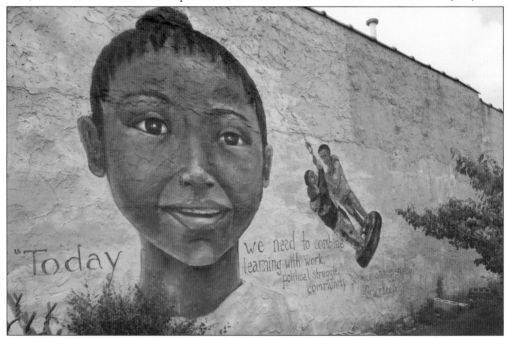

Activism cannot be discussed in the corridor without mentioning Detroit Summer, a movement started in 1992 by Grace Lee Boggs. The multicultural, intergenerational collective envisioned to mirror Freedom Summer of the 1960s is designed to rebuild and redefine Detroit from the bottom up. This mural, off of Second Avenue, celebrates Boggs's philosophy through her own words: "Today we need to combine learning with work, political struggle, community service, and even play." (EK.)

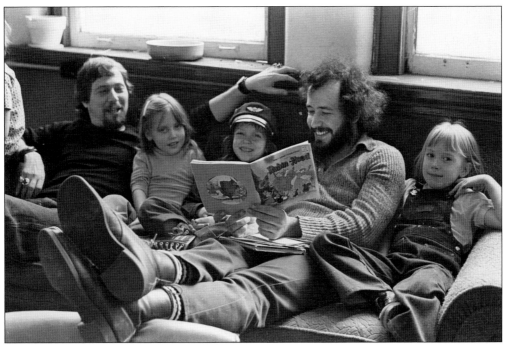

Activism in the corridor has led to alternative tracks of education, like the YouthBuild Detroit program geared to teach building trade skills and the Detroit Children's School that ran from 1971 to 1979. Above, iconic Cass Corridor photographer Ralph Rinaldi is seen reading a book to some of the students during storytelling time. The image below is a poster printed by Rinaldi that announces a festival fundraising event for the school. Note all the landmark establishments of the corridor. (Both, RR.)

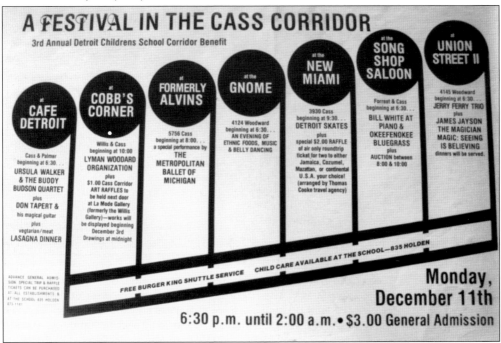

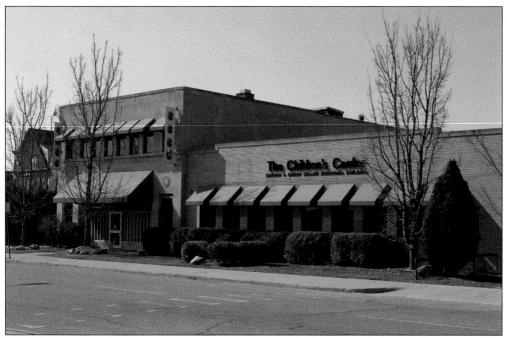

The Children's Center, a family services organization, is an anchor in the corridor. Founded by former US senator and Detroit mayor James Couzens in the late 1920s, the agency helps children and families from across the city and Wayne County. (MP.)

Located at the south end of the corridor on Ledyard Street off of Cass Park, the *Michigan Chronicle*, founded in 1936, is the oldest and most respected African American newspaper in the state. Started on a shoestring, the newspaper became a voice of the black community as it fought for civil rights and dignity, both socially and politically. The current building was once home to Paramount Pictures when the area was the hub for film distribution in Detroit. (RDR.)

The Cass Corridor would not be so colorful if not for its landmark bars and entertainment venues. The Gold Dollar, originally opened in the 1930s as a beer garden and closed in 2001, was most recently known as a musical venue for budding rock groups, such as the White Stripes. In a previous incarnation, the bar was infamous for drag shows and was a hot spot in Detroit's gay nightlife from the 1950s through the 1980s. (RL.)

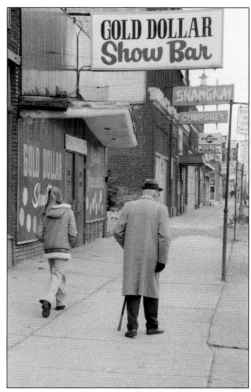

Bill's Recreation is another unforgettable institution in the corridor. Located on Third Avenue just north of Martin Luther King Boulevard, the pool hall was named after the original owner, Bill Epps, who knocked down the interior walls of the 1921 three-storefront building to create a house of recreation. Both snooker tables and pocket billiards shared the floor until the latter took precedence in the late 1970s. Mel Bridges, pictured, has been frequenting the establishment since 1964. (EK.)

The Comet Bar & Grill, located on Henry Street at the southern edge of the Cass Corridor, is another anchor in the area's nightlife. Built in 1923, the building housed the Pantry Bar through the mid-1950s, after which the name was changed to the Comet Bar. Located in the part of the corridor that has been hit hardest economically and socially, the Comet's survival is somewhat of a miracle. (EK.)

Third Avenue's commercial decline by the 1980s has had a few stubborn survivors. Jumbo's Bar, coined for original owner Steve Demoff's nickname, opened in the early 1940s. "Jumbo" was known for taking care of his clients, even if some found their way into trouble with the authorities. He was affectionately called the "Mayor of Third Street." His daughter Cindy Furkovich now runs the landmark. (EK.)

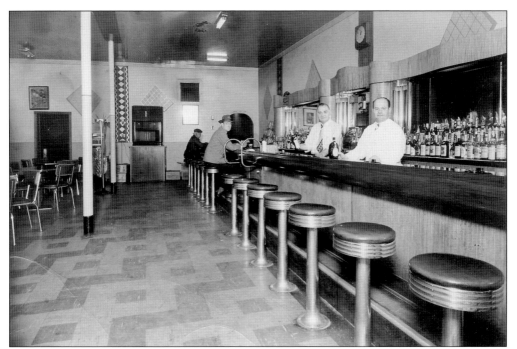

The Temple Bar, opened and operated by the Boukas family since the 1920s, has been active in and witness to the colorful history of the corridor. Located on Cass Avenue, across from the Masonic Temple, the bar boasts one of the first 100 liquor licenses issued by the city. This is a 1950s photograph of the interior. (GB.)

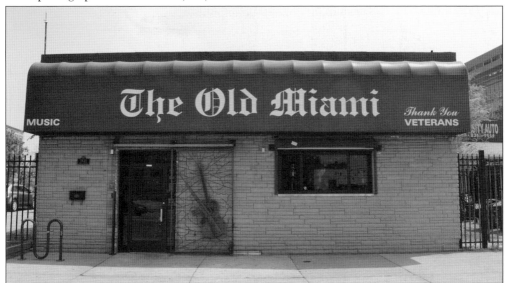

The Old Miami, originally built in 1923 on Cass Avenue as an auto service station, became the Miami Lounge in the 1940s, and then Ken's Lounge in the 1960s. A rough hangout, for only the brave, it caught fire and had to close but reopened in 1977 as the New Miami. No stranger to bad luck, the bar was firebombed, causing it to be shut down yet again. The current incarnation has had a nice run as a hangout for veterans and young hipsters who gravitate to its homey interior, dance floor, and outdoor patio with fire pit. (RDR.)

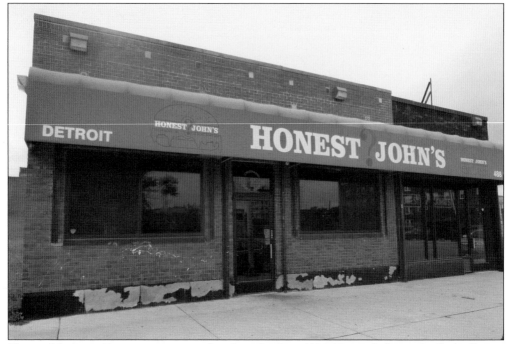

Honest John's is a Detroit institution that dates back to 1990. Formerly located off of Jefferson Avenue across from Belle Isle on the east side, original owner John Thompson, a child of the corridor, moved the bar to Selden Street between Cass and Second Avenues in 2002. Inside the 1938 building that was formerly home to Elmer's Bar and Selden Barbecue from the 1940s, the bar is known for both its humor in decor and its commitment to social justice causes. (MP.)

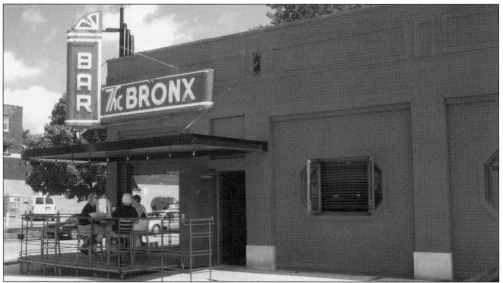

The Bronx Bar, originally built in 1921 on the corner of Second Avenue and Prentis Street as a grocery store, has been the locals' watering hole for decades. Students from Wayne State University and longtime residents come here for easy conversation, no-frills beer, and a tasty burger with timeless favorites reverberating out of the jukebox. Owners Paul Howard and Scott Lowell have spruced up the place while maintaining its original cavernous character. (EK.)

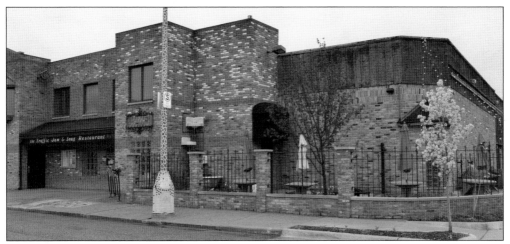

The Traffic Jam and Snug, opened in 1965 at Second Avenue and Canfield Street, is another favorite for university alumni and visitors. The two buildings, constructed in 1892 and 1924, respectively, were previously home to the Palm Garden restaurant, the Honey Bee restaurant, and Paolo's pizzeria. Today, the restaurant complex contains a microbrewery, bakery, and dairy and is known for its eclectic menu in a casual, general store–like setting. (SL.)

The Cass Cafe, opened in 1993, has taken over where Verne's and Cobb's Corner left off. A gathering place for local artists and freethinkers, this bar and restaurant, owned by longtime corridor personality Chuck Roy, is the hands-down standby for neighborhood residents and undergraduates from Wayne State University and the College for Creative Studies. The casual atmosphere is complemented by great drink specials, rotating art by local talent, live music, and its signature lentil-walnut burger. (SM.)

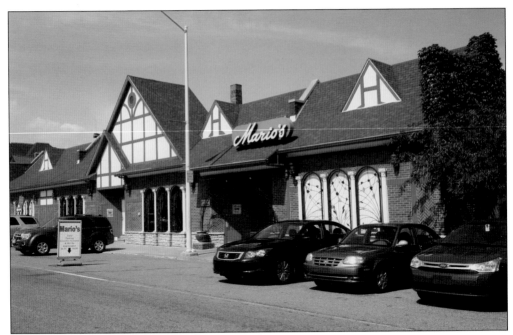

Mario's, located on Second Avenue near Willis Street, has been serving northern Italian cuisine to area mafia and others since 1948. Initially a car sales and service facility built in 1929, it changed to light manufacturing in the 1940s to serve the war effort and then was converted into the present-day restaurant. An unpretentious yet classy establishment with old-world service, Mario's continues to draw clientele from all over the metro area. (AMD.)

Third Avenue Hardware, owned by George Sultana (left) and comanaged by his siblings Victor (center) and Sylvia (right), has been serving the neighborhood since 1953. Their friendly and dedicated service distinguishes them from big-box home improvement stores. Moreover, Sultana's knowledge of the corridor's old buildings and quirks makes otherwise intractable problems manageable for home owners and renters alike. (EK.)

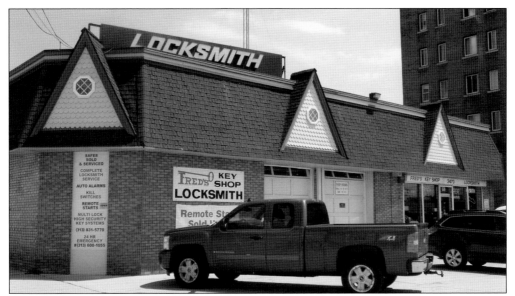

Fred's Key Shop, currently located at Second Avenue and Martin Luther King Boulevard, is the most famous key shop in the city. Fred Knoche and his six brothers have been running the store since 1962. Prostitutes, drug peddlers, and vagrants loitered outside while Fred and his staff served a range of clients, from the mayoral mansion and skyscrapers to sports celebrities locked out of their cars to neighborhood senior citizens having trouble with door locks. (EK.)

Converting a former secretary of state Art Deco building from the 1930s, Philip and Ryan Cooley opened Slows To Go Restaurant in 2010 on Cass Avenue and Alexandrine Street. This, their second location, adds to the momentum of the Cass Corridor redevelopment. Building on collaboration among corridor businesses, Slows is partnering with Hot Spokes, a local, independent bike delivery company, to bring food to customers with zero emissions used during transport. (RDR.)

Shangri La is a Chinese restaurant that opened in 2009 and is managed by Raymond Wong (seen here). Its opening on Cass Avenue north of Forest Avenue was welcomed after Chung's, the last of the Chinatown restaurants farther south in the corridor, closed in 2000 after 40 years of operation. Shangri La occupies the previous space of Twingo's, a popular French-themed bistro. (MC.)

Motor City Brewing Works, a tremendously successful microbrewery with brick-oven pizzas, opened in 1994. The bar, currently owned by John Linardos and Dan Scarcella, hosts local artist shows every Wednesday night. Located in the back of a parking lot on Canfield Avenue between Second and Cass Avenues, the building was erected on the former site of the Sweet 16 bottle shop. (RDR.)

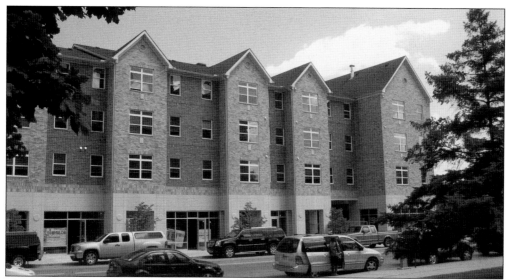

The Christian Science Reading Room, located in a 1939 Neoclassical structure on Cass Avenue between Warren and Hancock Avenues from 1961 to 2010, had a long history in the corridor. This venue of the First Church of Christ Scientist, originally located on Alexandrine Street in the 1890s and then Hancock Avenue in 1917, closed its doors definitively in 2010 to make room for the Union at Midtown (pictured). This multiuse complex with retail and apartment space is marketed to university students and exemplifies the ever-changing face of the Cass Corridor. (EK.)

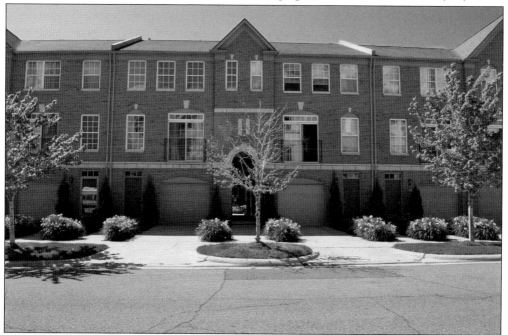

Another important component in reviving depressed areas is physical density in the housing stock. Pictured above between Cass and Second Avenues are the Hancock Square townhomes built in 2001 and anchored by the Hilberry Theatre and the Renaud Apartments. This infill housing eliminated vacant lots and increased pedestrian traffic, creating a safer, livelier street scene. (RDR.)

The Furniture Factory, located on Third Avenue between Canfield and Willis Streets, is now a multipurpose building that is used for live theater, artist shows, special events, and business operations. Built in 1923 by the Weber Furniture Company, the structure was used as both a retail and warehouse space. Current owner and local developer Akbar Noorbakhsh, pictured here in the lobby, put public and private grants to work to modernize the space for its current use. (EK.)

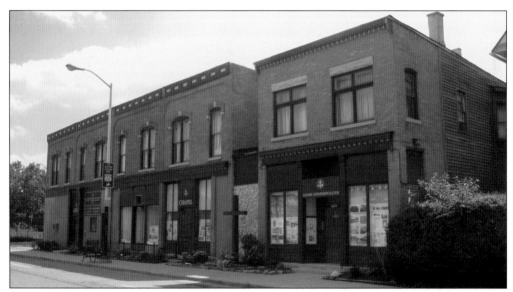

Another adaptive use of older buildings is this string of Third Avenue storefronts erected in the 1880s and 1890s and part of the Brown Evangelistic Ministries. The buildings are significant, as they are the last remaining commercial structures from the 19th century at the time of the Third Avenue streetcar line initially powered by horses and, later, electricity. (EK.)

Located south of Martin Luther King Boulevard on Cass Avenue is CanineToFive, a dog grooming and boarding facility. Built in 1949, it was the Masonry Auto Parts Store for a number of years until current owner, Liz Blondy (pictured) opened her business in 2006. Blondy has recently modernized the facade, increased her staff from one to eighteen, and planned a facility expansion for 2012. (AD.)

People's Records is one of the few remaining record shops in the city. Their current location on Woodward Avenue is in the former Studebaker dealership showroom built in 1913. The building lies on the southeastern edge of the corridor, and owners Brad Hales (left) and Andy Moran, with Irma the watchdog, are pictured here. (RDR.)

Detroit School of Arts, built in the early 2000s on Selden Street and Cass Avenue, is an example of institutional investment by Detroit Public Schools in the revitalization of the Cass Corridor. In collaboration with the Detroit Symphony Orchestra, Detroit School of Arts offers a performing-arts curriculum to high school students, as well as unique opportunities to work with the professional musicians of the orchestra. (RDR.)

The first school in the Cass Corridor when it was established as Cass Union in 1861, Cass Technical High School bears a rich history. The landmark building, erected in 1919 and lauded for its architectural beauty, was closed in 2004 and demolished in 2011. The new, ultramodern Cass Tech is pictured above, heralding a new era for Cass students. (RDR.)

Entrepreneur and visionary Claire Nelson opened up the Bureau of Urban Living, a home goods and novelty boutique, on the ground floor of the Canfield Lofts in 2007. Nelson, pictured here, has developed a passion for Detroit, launching Open City, a network for existing and aspiring business owners to share their experiences to promote success in new ventures and create a more vibrant city core. (EK.)

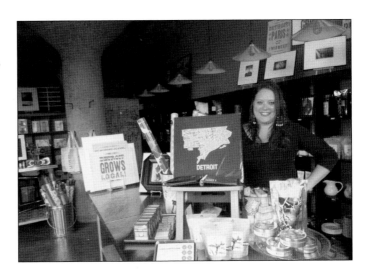

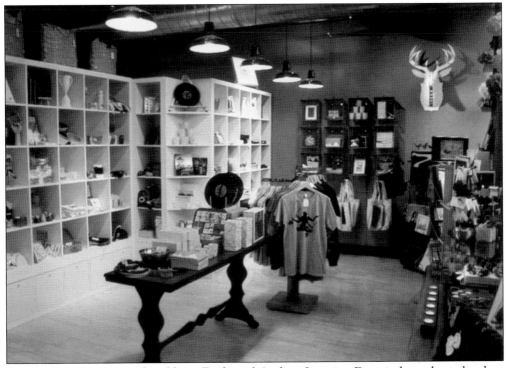

City Bird, a joint venture by siblings Emily and Andrew Lim, is a Detroit-themed novelty shop opened in the Canfield Lofts in 2009. From photographs and T-shirts to bar glasses with Detroit neighborhood names etched into them, the store has become a destination for the entire metro region. Located next to the Bureau of Urban Living, the two stores often collaborate to throw street fairs with live music, food, and other independent vendors touting their wares. (CB.)

105

The Cass Corridor is not only a physical location with bars, buildings, and residences, it is a space where life is celebrated by the people of the corridor through seasonal gatherings, festivals, and parties. Most recently, clustered businesses on Canfield and Willis Streets have sponsored their own street fairs and block parties. Sprinkled with live music, food, drink, and independent vendors, these events are attended with great excitement for all. Pictured above, from left to right, are local business owners Claire Nelson, Emily Lim, Jackie Victor, and Nefertiti Harris. (Both, CB.)

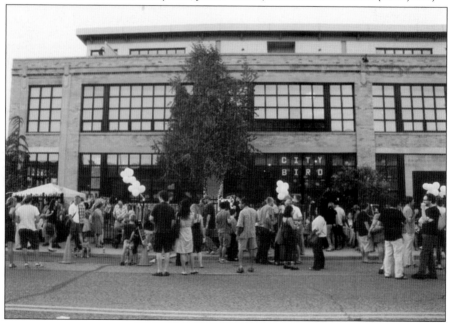

The Willy Overland Lofts, a building that once hosted the 1918 auto show, now provides stunning living spaces and is one of the most coveted addresses in the corridor. Located on Willis Street between Cass and Second Avenues, the street has become the prototype for redevelopment, thanks in large part to the diversity of establishments concentrated in a small, walkable area. (MP.)

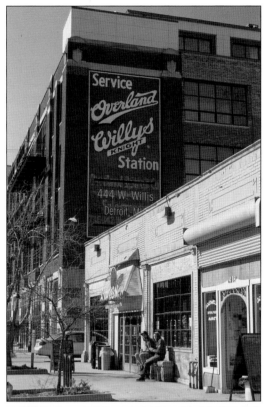

On the ground floor of the Willy Overland Lofts is Re:View Contemporary Gallery, opened in 2010 and owned and operated by Brazilian artist Simone DeSousa (pictured here). Attracted to the corridor's authenticity, industrial history, and a welcoming environment where meaningful human interactions are valued, DeSousa hosts a series of exhibits from local and international artists. Her collaborative, entrepreneurial spirit is motivating others to open area galleries. (EK.)

107

The Spiral Collective, on the corner of Willis Street and Cass Avenue, was originally built in 1924 as a grocery store. The famous Cobb's Corner bar was the landmark there in the 1960s and 1970s and was succeeded by the Cass Corridor Food Co-op until 2002. The Spiral Collective houses three independent businesses: Tulani Rose, a lifestyle boutique operated by Sharon Pryor (left); Source Booksellers, operated by Janet Jones (center); and the Dell Pryor Gallery, owned by Dell Pryor (right). (EK.)

Goodwells Natural Foods, located on Willis Street between Cass and Second Avenues, is a welcome replacement for the Cass Corridor Food Co-op that closed in the early 2000s. Opened in 2006 by James Wood (pictured), Paul Willis, and Garry Mixon, this store embraces an environmentally friendly, ecologically sound approach to the sale of its products and its daily operations. (EK.)

Flo Boutique on Willis Street next to Goodwells Natural Foods and Spiral Collective is an eclectic clothing boutique that highlights originality and creativity in design. Owned and operated by Felicia Patrick since 2003, the store has added much color and diversity to the West Willis Street block. (EK.)

Textures by Nefertiti, located on Cass Avenue just south of Willis Street, is a pioneer business in the revitalization of the corridor. Opened in 2002, the inviting space is known as a mind, body, and spirit hair spa, cultivating beauty from the inside out. Proprietor Nefertiti Harris is pictured outside of her establishment. (EK.)

Avalon International Breads, located on Willis Street between Cass and Second Avenues, is perhaps the most widely recognized business in the Cass Corridor. Occupying the space of the famous Willis Gallery, the establishment is known for its commitment to building community through the Buddhist philosophy of "right livelihood" business. Started in 1997 by Ann Perrault (left) and Jackie Victor, pictured below, the business supports three bottom lines: earth, community, and employees. The store contains an intimate retail cafe space, along with a wide-open production facility where customers can watch all stages of the bread being made. Avalon uses organic flour in its baking and has become one of the largest bread distributors in the Metro Detroit area. (Above, AB; below, FP)

Curl Up and Dye, located on Cass Avenue in the 1916 Stuber Stone building, is a newer hair salon in the neighborhood. Opened in 2008 by Jennifer Willemsen, the shop has seen record sales, increasing its client base from 1,000 to 3,500 in less than two years. The salon distinguishes itself from competitors by embracing the green movement; it is the only salon in the area that offers organic hair, skin, and nail products. (EK.)

The University Cultural Center Association is the sponsor of the annual Noel Night, when all the museums located on the perimeter of the corridor—along with Wayne State University, the Center for Creative Studies, and neighboring churches, galleries, and boutiques—celebrate the holidays with open houses, live music, and countless activities for all ages. Centered on Woodward and Cass Avenues, thousands stroll the streets, reveling in the music, food, and gifts of the season. (MD.)

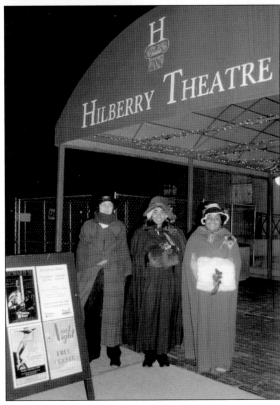

Every September, the Cass Corridor plays host to the most popular noncorporate-sponsored music festival in the state. Dally in the Alley started in 1978 under the name Gali Mufrey, but the name changed when Gini Fox questioned the proposal in 1982 to move the event from Second Avenue to the alley between Forest Avenue and Hancock Street. She referred to a medieval drinking song, quipping, "People dally in the alley!" And the rest is history. (Both, NCCU.)

The Dally brings back the Cass Corridor residents of the 1960s and 1970s, giving the festival a counterculture, hippie feel unlike any other music festival. Moreover, there is consistently a waiting list of the greatest musical talents in the city who ask to play (for free) on a stage at Dally. Allen Schaerges, pictured below at Motor City Brewing Works, obtained the first liquor license for the Dally and has helped oversee the annual event ever since. His jovial nature imbues the festival with a carefree happiness, winning him the affectionate title of "Mayor of the Dally." Dally is a tribute to and living legacy of the creative, collectivist spirit that defines the Cass Corridor. (Right, RR; below, EK.)

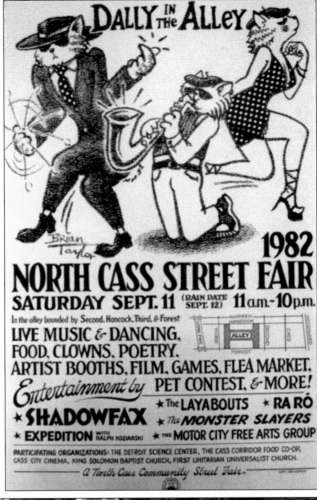

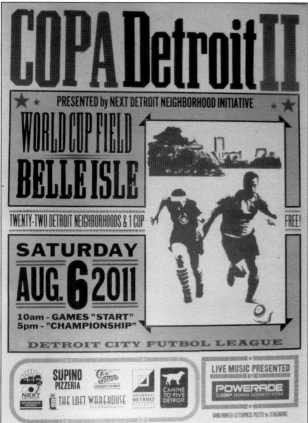

COPA Detroit II

PRESENTED by NEXT DETROIT NEIGHBORHOOD INITIATIVE

WORLD CUP FIELD
BELLE ISLE

TWENTY-TWO DETROIT NEIGHBORHOODS & 1 CUP FREE!

SATURDAY
AUG. 6 2011

10am - GAMES "START"
5pm - "CHAMPIONSHIP"

DETROIT CITY FUTBOL LEAGUE

SUPINO PIZZERIA
Sauce SOUTHWEST DETROIT
NEXT neighborhood initiative
THE LOFT WAREHOUSE
SOUTHWEST DETROIT BUSINESS ASSOCIATION
CANINE TO FIVE DETROIT

LIVE MUSIC PRESENTED by
POWERADE ION4 ADVANCED ELECTROLYTE SYSTEM

HAND-PAINTED LETTERPRESS POSTER by STURNBURG

In 2010, the Detroit City Futbol League was formed as a recreational soccer league for young adults in Detroit. Each team represents a neighborhood, with teams squaring off once a week during the summer, culminating in a final one-day tournament in August called the COPA. In 2011, the number of teams and participants in the league doubled, owing to the popularity of the activity and the recent influx of young people back into the city core. In the image above, players from the Cass Corridor team pose proudly, while the hand-painted poster announcing COPA 2011 is pictured at left. There is no doubt the joie de vivre has returned to the Cass Corridor. (Above, MB; left, BS.)

Six

THE FUTURE

Behind every sustainable community is a core of dedicated residents and visionaries whose success is predicated on cultivating good human relations. Harmony between old and new residents, institutions, and retail has been nurtured through an open, collaborative spirit that has defined the corridor since the 1960s. The Cass Corridor is the heart and soul of the wider, rebranded area known as Midtown Detroit. The corridor survived and now prospers precisely because of its spirit of solidarity, defending it against homogenization.

What makes the area so attractive today is the consensus of thought that the success of one should and can contribute to the success of all. In this vein, shop owners collaborate instead of compete, simultaneously sharing their client bases and building community. Midtown has a bright future, thanks to the people and personalities of the corridor.

More projects are underway and on the drawing board for Midtown. Behind these undertakings is the indomitable spirit of many approachable movers and shakers who continue to build the Cass Corridor of tomorrow. From the Midtown Loop, a greenway running through the heart of the corridor that will eventually connect with the city's river walk, to the Green Garage, a former car dealership converted into a small-business incubator that uses the most advanced and stringent environmental standards to date, many are redeveloping the corridor with a quality of life that will be a model to emulate for years to come.

The Midtown Loop running down Cass Avenue from Kirby Street to Canfield Street and continuing east to John R Street east of Woodward Avenue will be a two-mile greenway designed to reclaim right-of-way for pedestrians, beautifying the path with planting beds, unique lighting, and public art. The loop is designed to help connect Midtown with the iconic Eastern Market and the Detroit Riverwalk. Half of the loop had been completed as of mid-2011. (AMD.)

The Green Alley is a project of the Green Garage and University Cultural Center Association (UCCA) that transformed a most undesirable space—a city alley—into a sustainable community greenway, using indigenous plants, reclaimed bricks, and solar energy for lighting. Completed in 2010, the project is designed to serve as a model for sustainable alleys throughout the city, country, and world. (MC.)

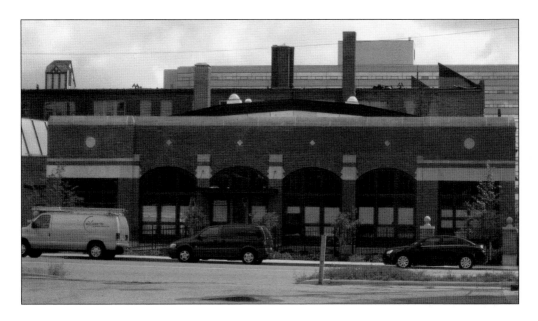

The Green Garage, located on Second Avenue south of Prentis Street, is a business incubator that embodies the next generation of turning environmental creativity into reality. Built in 1920 for the Detroit Ford Motor Truck Company and used as the Harr-Oldsmobile Company auto dealership in the 1930s and subsequently as a service station and storage, the building has been reconfigured using the latest and most stringent environmental standards to create a green facility that will be used as a business incubator. Developers Tom (pictured below, inside the facility) and Peggy Brennan have directed and are deservedly proud of this transformation for Detroit's sustainable future. (Both, EK.)

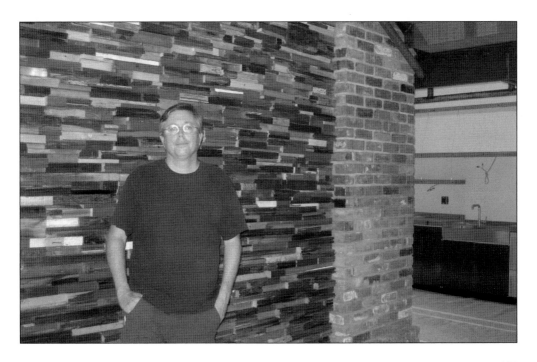

The North Cass Community Garden on Second Avenue and Willis Street is a 2009 addition to the neighborhood. The project combines the spirit of communal space with the growing popularity of urban farming in Detroit and beyond. (RDR.)

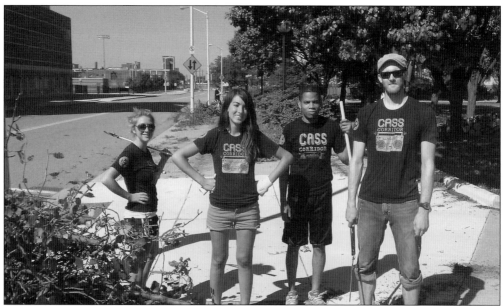

The energy of youth and renaissance has descended upon the Cass Corridor. The current generation is taking ownership of the space and remaking it a hub of hip and authentic city living. Pictured are young professionals volunteering their time to clean up Cass Park. With this sustained effort, the future of the Cass Corridor is bright. (FG.)

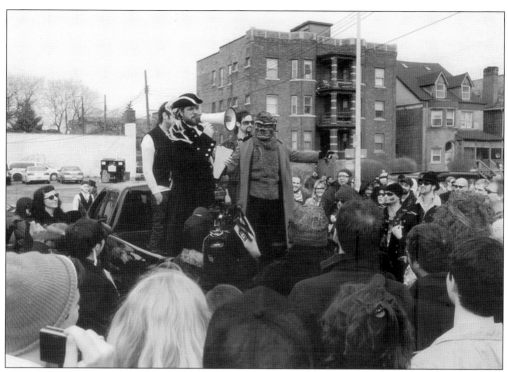

La Marche du Nain Rouge, the brainchild of Francis Grunow and Joe Uhl, is a Detroit tradition revived in 2010 and already becoming a corridor and city classic. Every vernal equinox, a red dwarf that supposedly has plagued Detroit with evil since its French founding in 1701 is abolished through a communal parade that flows southward down Cass Avenue, culminating in an effigy-burning ceremony at Cass Park. Pictured above are Monsieur Livernois and le Nain Rouge. The fun event is another example of creative energy redefining the Cass Corridor. (Both, DS.)

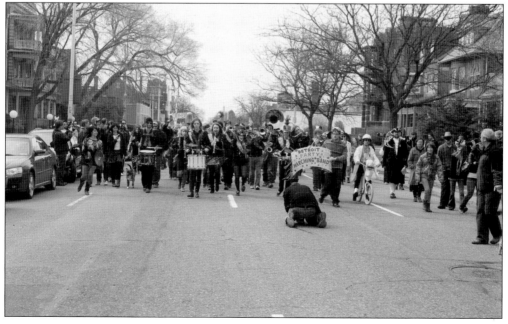

Sue Mosey, the hands-down mover and shaker for Midtown, has labored almost 25 years to rebuild the corridor and surrounding areas. With charisma, vision, and persistence, she has united institutions, private businesses, government bodies, and charitable foundations in a permanent dialogue about redevelopment. First allowing historical district designations to access federal and state tax credits, Mosey and her staff at Midtown Inc., where she serves as president, are now the biggest advocates and most powerful players in facilitating all that is exciting and new in the area. (PH.)

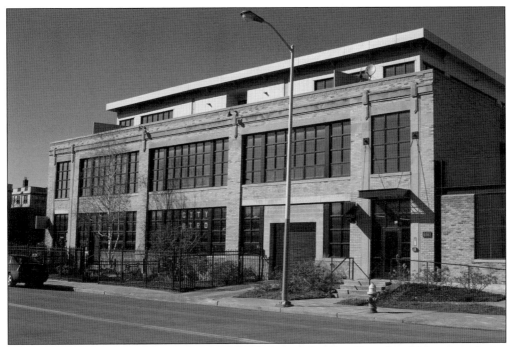

Colin Hubbell, one of the most influential developers in the Cass Corridor, died at an early age in 2008. He was responsible for many projects, most notably the Canfield Lofts, pictured here. Formerly the Buick Motor Company's garage and service station, built in 1921, Hubbell's was the first major loft conversion in the corridor. A memorial fund in his name has proven to be a key in the continued redesign of Midtown Detroit. (MP.)

Pioneer developer Robert Slattery has radically reshaped the Cass Corridor for the better. The Venn, on Cass Avenue, is a stately Beaux Arts structure built in 1904 by the Venn family. The building, having been subdivided into small apartments, was turned into six luxury condos in 2001. Slattery's work on the Venn can be regarded as the seminal event in the redevelopment of the Cass Corridor. (RDR.)

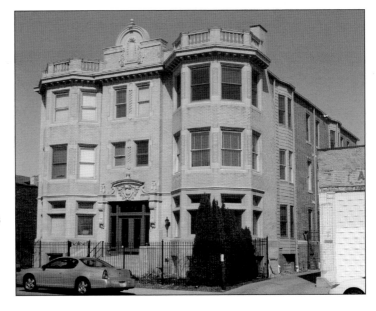

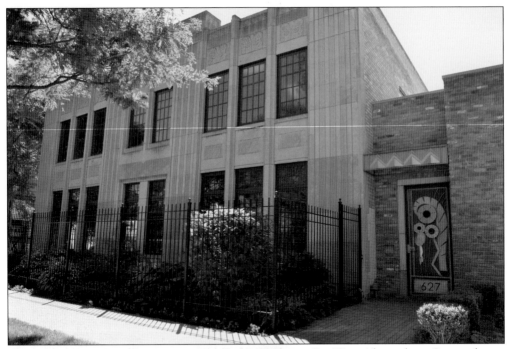

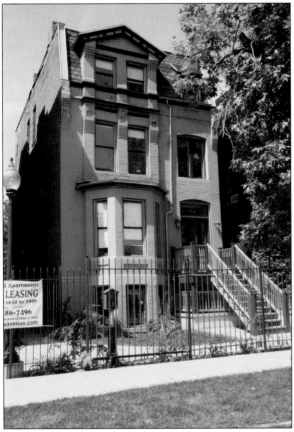

On West Alexandrine Street, the Springfield Lofts occupy an Art Deco building. Constructed in 1930, it originally housed a retail outlet for the Springfield Metallic Casket Company. By 1957, Wayne State University purchased the building for use in mortuary science courses. In 2002, the building was sold to local developer Robert Slattery, who turned it into 10 luxury loft condominiums. Its popularity indicates the Cass Corridor's renewed appeal to professionals. (RDR.)

A child of the 1960s, Joel Landy planted roots in the corridor and is now a major developer in the area. Landy owns more than 50 parcels in the Cass Corridor, including the former Burton, Jefferson, and Couzens Schools. Landy bought and refurbished many buildings in the area. A community developer, he has invested upward of $40 million in the neighborhood in the last 15 years. One of the houses he renovated is pictured at left. (AMD.)

The Blackstone (right) on Second Avenue, built in 1917, and the Beethoven (below) on Third Avenue, built in 1921, are both just south of Prentis Street and excellent examples of apartment buildings with dignified beginnings that saw horrible neglect thereafter. Fortunately, the vision of Cass Corridor developer Scott Lowell, who bought both properties in the last 10 years, recently has been realized through his dedication to refurbishing and modernizing both buildings for quality market-rate housing. Lowell, like other developers in the corridor, has leveraged his own assets, as well as taken advantage of public and private sector incentives designed for historical rehabilitation. The financing of such projects is often tedious but proves rewarding for the developer, future residents, and the community at large. (Right, EK; below, MC.)

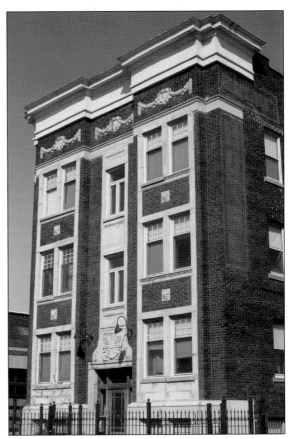

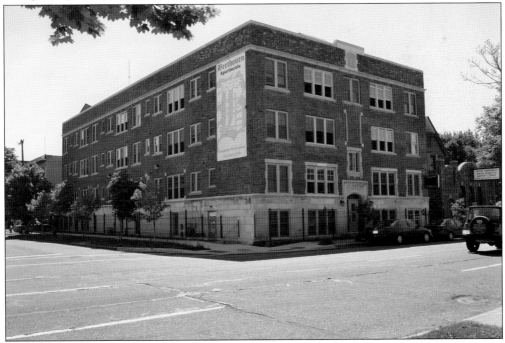

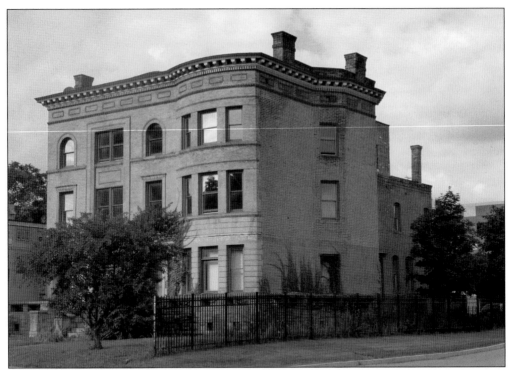

Another project of local landlord and developer Akbar Noorbakhsh, the Boydell is a stately Beaux Arts building located on Cass Avenue just south of Forest Street. The 1895 structure was designed as a two-unit dwelling for the wealthy of that era. Noorbakhsh is restoring the space with modern amenities, with a vision of a restaurant on the main floor and apartments above. (EK.)

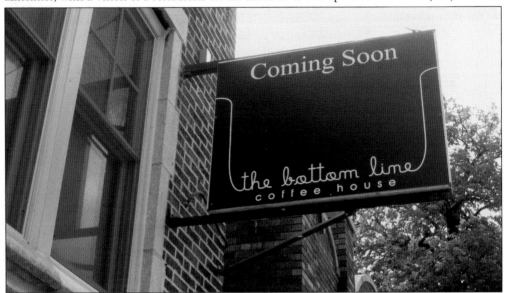

The Bottom Line Coffee House, located on the lower level of the Beethoven Apartments on Third Avenue and Prentis Street, is a new neighborhood cafe opened by Al and Pat Harris and their son Kyle in the fall of 2011. Another example of budding small businesses, the coffeehouse caters to university students, staying open late as an alternative to bars in the Cass Corridor. (EK.)

Formerly the Rayis Party Store, this one-story building located on the southeast corner of Cass Avenue and Willis Street stood vacant for much of the first decade of the 21st century until longtime residents Peter and Leslie Malcolmson bought the structure. Transforming an eyesore into the attractive facade shown here, the building will house two to three small retail establishments. (EK.)

Formerly Astro Distributors and two doors south of the building in the photograph at the top of the page on Cass Avenue, is another one-story building constructed in 1918 as an automobile service station and garage. The building was bought in 2011 by artist Adnan Charara and is being extensively reconfigured inside and out. Charara is planning storefront retail, a large graphic design and art gallery in the middle, and a sculpture, printmaking, and painting studio in the rear. Charara, pictured in the construction site, exemplifies the vision and investment sweeping the corridor. (EK.)

Live Midtown, another project coming from Midtown, Inc., is a plan to attract 15,000 new residents by 2015 through rental and buying incentives. The area will become an even greater destination when the current proposal for light-rail transit on Woodward Avenue is realized by 2015. Pictured is a rendering of the proposal. (CD.)

The Cass Corridor has a fascinating lore. The website corridortribe.com was created in 2001 to provide current and former residents an opportunity to reconnect and retell the stories that defined them and the era. Additionally, Douglas Ekman wrote and narrated an audio anthology of 14 short stories entitled *People Live in the Cass Corridor.* There is no doubt that additional works on the corridor will be forthcoming. (DE.)

Authors Elias Khalil (left) and Armando Delicato relax in Khalil's Cass Corridor backyard, reveling in the area's renaissance and soaking up summer in the city. (AD.)

Discover Thousands of Local History Books Featuring Millions of Vintage Images

Arcadia Publishing, the leading local history publisher in the United States, is committed to making history accessible and meaningful through publishing books that celebrate and preserve the heritage of America's people and places.

Find more books like this at
www.arcadiapublishing.com

Search for your hometown history, your old stomping grounds, and even your favorite sports team.

Consistent with our mission to preserve history on a local level, this book was printed in South Carolina on American-made paper and manufactured entirely in the United States. Products carrying the accredited Forest Stewardship Council (FSC) label are printed on 100 percent FSC-certified paper.

MADE IN THE USA